IMAGES
of America

HEMPSTEAD
VILLAGE

ON THE COVER: The Hempstead Bank building in 1910 dominated the intersection of Fulton Avenue and Main Street, in the heart of the village's business district. Completed in 1907, thirty years after the bank itself was founded by Martin V. Wood and Edward Cooper, this edifice housed a proud and long-lived bank as well as the village government offices and police station. It remains a well-loved historical site. (Hempstead Public Library.)

IMAGES
of America

HEMPSTEAD
VILLAGE

Reine Duell Bethany
Foreword by Mayor Don Ryan

ARCADIA
PUBLISHING

Copyright © 2018 by Reine Duell Bethany
ISBN 978-1-4671-2815-5

Published by Arcadia Publishing
Charleston, South Carolina

Printed in the United States of America

Library of Congress Control Number: 2017949777

For all general information, please contact Arcadia Publishing:
Telephone 843-853-2070
Fax 843-853-0044
E-mail sales@arcadiapublishing.com
For customer service and orders:
Toll-Free 1-888-313-2665

Visit us on the Internet at www.arcadiapublishing.com

To my mother, Ellen Duell; my husband, Charles Bethany; and our children Marigold, Ariel, Ian, and Justin, all of whom unflinchingly encourage me.

CONTENTS

FOREWORD

I am thrilled that Hempstead Village has become a part of the *Images of America* series. The fact that it was published in the same year of our village's 375th anniversary makes it that much more special. Kudos to village historian Reine Bethany for authoring this incredible chronicle that captures the essence of Hempstead's past and helps provide a glimpse toward our future.

Hempstead Village is the only home I've ever known. My dad, raised on a farm in Muncie, Indiana, met a woman (my mom) from East Harlem, New York, and somehow, they settled in Hempstead Village to raise a family. Priceless!

My fondest memories of Hempstead Village lie in cherished relationships forged over 70-plus years, 33 of them as an educator at Hempstead High School. One is meeting Ollie Mills in 1957 as a ninth grader and playing on the first team he ever coached. Years later, I became the proud godfather of his older daughter. Another important figure is Lou Zara, a teacher who served as a mentor and ultimately encouraged me to take over his position teaching business law at Hempstead High School when he retired. And I vividly remember basketball immortal Julius Erving joining the Salvation Army Youth program as a 12-year-old in 1962.

Another memorable venture for me was heading the Neighborhood Youth Corps for over 25 years. This job placement program improved the employability of several thousand youngsters through paid work experience while encouraging them to remain in school and strengthen responsible attitudes. The corps also had classroom training components in reading, math, and life-coping skills.

Serving as a volunteer coach for the past 56 years has also brought great joy to my life. I'm convinced our youth are the backbone of Hempstead's future.

Despite the ongoing challenges that exist all around us and the changes Hempstead Village has witnessed throughout its long history, the great connection that exists between our educators, parents, and community continues to produce a strong contingent of leaders of tomorrow. That achievement makes me confident that Hempstead Village's finest days lie ahead. Enjoy the book.

—Mayor Don Ryan

ACKNOWLEDGMENTS

Space does not permit naming all who helped with this project, but salient ones are: former Hempstead Village mayor Wayne J. Hall Sr., who first appointed me Hempstead Village historian and provided foundational project support; current mayor Don Ryan, whose own brief but thoroughly researched histories of Hempstead education and sports alerted me to vital points; A. Patricia Moore, lifetime active resident, still involved with charity work here; Mayor Ryan's secretary, Jenise Richardson, tireless handler of questions; Liz Gurley, my editor at Arcadia Publishing, whose unwearied explanations of image handling have been as important as her cogent remarks on my writing; Irene Dusckiewicz, Hempstead Public Library director, who connected me both to the library's detailed archives and to further archive training; Steve Rung, Hempstead reference librarian and local archivist, who cheerily scanned (and rescanned) the bulk of this book's images from the library's vast collection; Iris Levin, curator of the Nassau County Photo Archives Center, who fielded a dense stream of questions and image requests; Geri Solomon, Debra Willett, Victoria Aspinal, and Barbara Guzowski of Hofstra University Special Collections, who opened their archives and supplied critically important information and images; Tom Salzman, Town of Hempstead archivist and a Town of Hempstead Landmarks Preservation Commissioner; Dr. Joysetta Pearse, curator of the village's African American Museum; Bruce Massie and Andrea Smernoff, Hempstead reference librarians, who guided my use of archives; Hempstead librarian Denise Ferrera and longtime village resident Doris Hendrickson, through whom unexpected images from the 1960s came to light; Ena Taylor, historian at St. George's Episcopal Church, which my husband and I now attend; Joe Simone, Hempstead Building Department superintendent; George Siberón, head of the Hempstead Hispanic Civic Association; my friends of the Ingraham Estates Civic Association; and the *Hempstead Beacon*, the village's own newspaper since 1951.

Unless otherwise noted, the book's images are from the archives of Hempstead Public Library. Images from the Nassau County Photo Archives are indicated by the abbreviation "NC"; those from Hofstra University Special Collections, Long Island Division, are indicated by "Hofstra"; and images provided by the author are indicated by the abbreviation "RB."

INTRODUCTION

Hempstead Village began on December 13, 1643, for two quite different reasons: the high ideals of its founders, and a problem that the Dutch government needed to solve.

The Dutch government gave the Dutch West India Company permission to set up a business at the mouth of the Hudson River, producing beaver and otter pelts for sale in Europe. A second mandate was to establish political control over areas now known as Manhattan, Staten Island, New Jersey, and western Long Island. The goal was to expand Dutch sovereignty in the Americas. However, even with imported African slaves to supply labor, few Dutch citizens accepted the invitation to leave Holland and create homes across the Atlantic. The Dutch crown then invited English settlers to the area, conditioned on the settlers agreeing to Dutch rule.

The Englishmen who responded to the Dutch were, at the time, part of a settlement in Connecticut. Their motives were not financial. Instead, the Englishmen hoped to establish a perfectly godly community with true freedom of thought and a peaceful, representative government. The English folks' leader was a vigorous, highly educated Presbyterian minister named Rev. Richard Denton. He had emigrated with his family from Halifax, Yorkshire, in northern England, to join the Puritan colony in Massachusetts Bay. However, that colony's political and religious atmosphere did not align with the ideas of Denton and others, so he and his group left and helped found first Wethersfield, and then Stamford, in Connecticut. Even there, Denton's disagreements with church and village leadership again goaded him to seek new opportunities. Two of his adherents, John Carman and Rev. Robert Fordham, crossed Long Island Sound late in 1643 to scout mid-Long Island. They blazed their way through the forested North Shore and emerged onto Hempstead Plains, where they beheld miles of waist-high blue-gray grass, threaded with waterways and ringed by gentle forests. These British farmers immediately saw the land's potential for raising stock and cultivating crops. John Carman came from a small town near London called Hemel-Hempstead, whose name may have been related to the Dutch town of Heemstede; either moniker could have influenced the choice of "Hempstead" to designate the area that became today's Town of Hempstead, which contains the Village of Hempstead (both located in Nassau County).

To start the new settlement was not a simple matter. The English recognized that the land they wanted was claimed by both the Dutch and the native people, whom the Dutch called Indians. The land could be deeded to the English, the Dutch said, if the "Indians" consented. Thus, Carman and Fordham met with Tackapousha, the sachem, or leader, of the Marsapeag (Massapequa) to the east. With Tackapousha were about seven other men, including representatives of the Mericock (Merrick) and the Rockaway peoples. Together, they hammered out an agreement for land use on December 13, 1643. In the spring of 1644, the Dutch granted the Englishmen their patent—political permission to occupy the land. To this day, the Village of Hempstead celebrates its origin as 1643, while the Town of Hempstead celebrates 1644.

Tackapousha's leadership of the mid-Long Island "Indians" did not end with the December 1643 land transaction. He tirelessly brokered peace and handled financial contracts between his people and the European settlers for 50 more years, until 1696, when his name disappears from historical writings.

By the spring of 1644, about 18 families followed Denton, Carman, and Fordham from Stamford to a site on the Hempstead Plains where two large brooks converged. Roughly 25 more families soon followed. Ponds dotted the area. Burleigh or Burley Pond stood near today's intersection of Fulton Avenue and North Franklin Street. Several hundred feet east of Burley Pond, most likely between present-day Main and Franklin Streets just north of Front Street, the settlers built a stockade surrounding a meeting-house. For the next two decades, this "town-spot" hosted worship, government transactions, and general community meetings; a larger structure then replaced it.

The agreement with Tackapousha gave the English folk property from Hempstead Plains in the middle of the island down to the South Shore, bounded to east and west by mutually agreed-upon north–south lines—some 64,000 acres. Hunting was abundant, the soil was fertile, and the growing season unusually long. The Hempstead Englishmen, many of them Yorkshiremen like Denton, were farmers rather than fishermen, so in preference to heading for the coastline, the families spread across the plains, setting up prosperous farms.

But though they spread out, their hub was still Hempstead Village. For the first two centuries of its existence, this hub remained tiny. It had the meetinghouse and a few taverns, which really functioned as hotels—most famously Sammis Tavern, established between 1660 and 1680 and in continuous operation for the next 250 years. European wars of the mid-1600s had transferred control of New York from the Dutch to the English by early 1665 (or late 1664 in some early history books, because England was then transitioning from the Julian to the Gregorian calendar); the American Revolutionary War transformed New York from an English colony to a self-governing state in the new United States; but Long Island remained a sparsely populated collection of farms and shoreline businesses, with room in its middle for improvised horse-racing tracks. By 1800, Hempstead Village was described as having nine houses and three taverns.

However, in 1802, the fledgling US government established postal service for the Long Island and New York area. Hempstead became the first US post office east of Jamaica. Abraham Bedell's big tavern became the site in which the post office was given space, and Bedell himself became Hempstead's first postmaster on September 22, 1802.

The village burgeoned subsequently. To St. George's Episcopal Church and Christ's First Presbyterian Church was added the Methodist Episcopal Church (now United Methodist Church), which started in 1812 when Rev. William Thatcher preached at Stephen Bedell's home. Bedell's house stood until 1922, but the Methodist congregation rapidly outgrew its walls. In 1820, a new Methodist Church building arose on Front Street two blocks from St. George's. In that same year, St. George's burned to the ground, and its present-day building replaced it on the same site in 1822. The Methodist Church replaced its 1820 building in 1855. The two churches' spires elevate the Front Street skyline to this day.

By 1840, S.C. Snedeker was postmaster, handling the mail from his store, S.C. Snedeker & Co. (dry goods, groceries, lumber, etc.), diagonally across Front Street from Abraham Bedell's tavern (which before long became Stephen Hewlett's hotel). Main Street between Fulton Street (now Fulton Avenue) and Front Street listed 31 businesses on an 1840 Queens County map, with another 16 businesses along Front Street, and 15 more down Greenwich Street. Hempstead may have looked to passersby like a sleepy village where not much was going on, but it already had a newspaper (the *Hempstead Enquirer*, established 1831) and a branch of the very new Long Island Railroad (LIRR).

Even now, there is far more of the inventive and the excellent occurring within Hempstead's present-day 3.7 square miles than many people realize.

During the 1800s, the United States continued to organize around its plan for making laws, known as the US Constitution, inspired by the promise of equality enshrined in the Declaration of Independence. The new nation now struggled with the agonizing problem of slavery. New York State passed one set of laws after another that gradually increased freedoms for African slaves. Officially, no more slaves could be owned, bought, or sold as of July 4, 1827, though vestiges of slave law were not completely abolished until 1841. When the Civil War began on April 12, 1861, Camp Winfield Scott on Hempstead Plains just east and a little north of the village provided training

for Union soldiers to fight against the slave-holding Confederacy of the Southern States.

Through all these events, through two world wars, through the decades that spawned the Civil Rights Acts of the 1960s, and on to the present, Hempstead has been an ultra-American center. Its originally white-dominated society burgeoned from those few taverns and houses in 1800 to the incorporated village in 1853, population 2,000, complete with its own schools, post office, fire department, board of trustees, and president (eventually board of trustees and mayor). Within 35 years of its incorporation it had established stable banks, a busy downtown, an LIRR terminal that ran trains to Manhattan and Brooklyn several times a day, and a trolley car system that carried passengers for decades. Grand houses arose on properties averaging seven acres. Theaters appeared from 1868 on, most famously those erected by Salvatore Calderone and his son Frank, inviting renowned US performers, live or in movies, to draw audiences from all around Long Island.

Family names of the original English and Dutch settlers appeared in religious and municipal documents into the 1970s, but these institutions and farms were not the product of white hands alone. In fact, the scale of Hempstead Village's development would have been impossible without its Native American and African workers, all too many enslaved, though there were also significant numbers of nonwhite freemen. The later industry and achievements of African Americans, Native Americans, Caribbean Americans, Asians, Puerto Ricans, Central Americans, and Middle Easterners are as integral to Hempstead's wealth and heritage as those of its white citizens.

As the village copes with the long-term effects of mall development sucking business away during the 1950s and 1960s, of the departure of major employers from Nassau County starting with the closing of Mitchel Field Airbase in 1961, of the nationwide crime waves of the 1970s through the 1990s, and through the 2008 economic crash, we find ourselves now more than ever conscious of our strength. The year 2018 marks our 375th anniversary. Our faces mirror the growing multi-ethnicity across our nation. We anticipate a future in which we model cooperation among our diverse citizens and demonstrate the potential of Americans to unite under the US Constitution, fulfilling the ideal of the good society envisioned by Hempstead Village's founders. Our past is magical and tumultuous; our future will go from strength to strength.

One

A DIVERSE BEGINNING

1643–1800

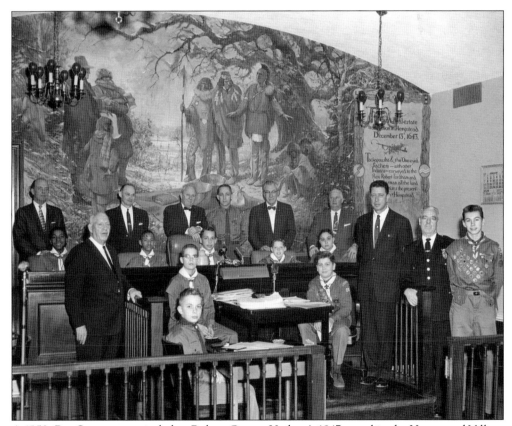

A 1950s Boy Scout group sits below Robert Gaston Herbert's 1947 mural in the Hempstead Village Hall courtroom. The mural commemorates Hempstead's beginnings: the 1643 land purchase agreement among Englishmen John Carman and Rev. Robert Fordham, and the Long Island native groups led by Tackapousha. The 64,000-acre tract was a mid-island prairie, with pastureland, streams, lakes, and ponds, edged by forests yielding wood for fuel and building.

Woods and streams surrounding Hempstead Plains supported abundant wildlife. A 1670 description by Daniel Denton, son of Richard Denton, the Presbyterian minister who led the Hempstead settlers, lists "deer, wolves, bear, foxes, raccoons, otters, musquashes, heath-hens, quails, partridges, widgeons, pidgeons," as well as trout in the streams. The scene in this c. 1918 photograph graced the village's southwestern edge, where water-rich woodland still exists.

Burley Pond at Fulton Avenue and Franklin Street is pictured in 1918. It once sat close to Hempstead's first meetinghouse (finished 1648), one among several ponds near the confluence of two streams at Hempstead's center. The meetinghouse, 24 feet square and guarded by a palisade, served the settlers' church, court, and social life until a new meetinghouse replaced it in 1673. Presbyterians, Independents, and Anglicans worshiped there.

At Hempstead Village's tercentenary celebration in 1943, villagers watched a colonial reenactment on Denton Green, the park in the village's center that commemorates Rev. Richard Denton. Elevated above the sea on level land, away from the storms that battered Long Island's coasts, Hempstead was a perfect hub for hosting community functions and storing supplies. Denton served as minister until returning to Yorkshire in 1659.

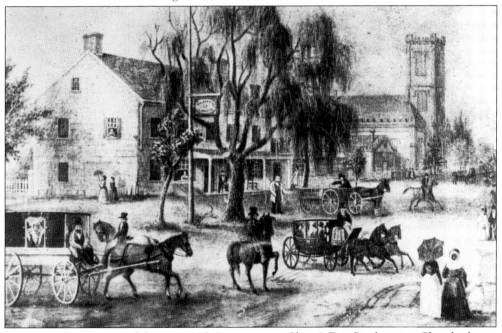

One church in Hempstead designates 1644 as its origin: Christ's First Presbyterian Church, shown here beyond Sammis Tavern in 1850. Denton and his followers were Presbyterian, though they accepted other denominations into worship meetings. Beyond the church was its graveyard. In the early 1900s, remains were removed to Greenfield Cemetery. Ancient headstones were decorously laid down and landscaped over to create Denton Green in the village's center.

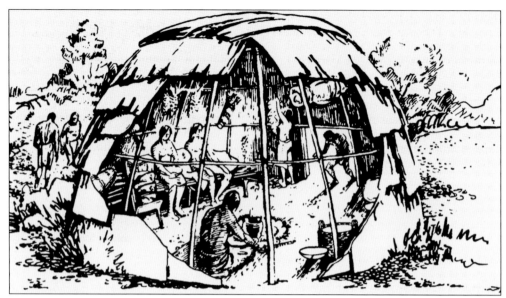

Recent historians do not follow Long Island's tradition of dividing its native people neatly into 13 tribes, but view the groups as self-defined by lineage and clan. Tribal names—Massapequa (Marsapeag), Merrick (Mericock), and Far Rockaway—reflected locations where the various groups had lived for centuries, some in dwellings like the wigwam pictured. (Garvies Point Museum and Preserve, Nassau County Department of Parks, Recreation and Museums.)

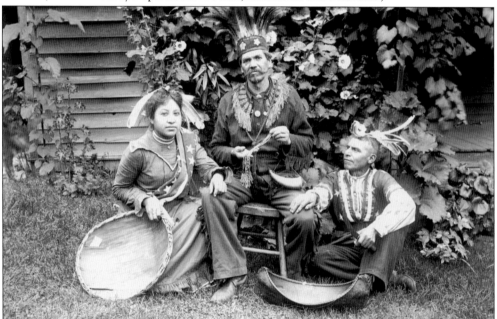

Pictured from left to right, Melinda Johnson, Albert Cusick, and Philip Green—Onandaga members from central New York State—pose in traditional native garb around 1910. Cusick holds wampum—decoratively strung beads carved from clam shells. Wampum was a form of Northeastern Native American currency. Eastern Long Island was renowned for the artistry and quantity of its wampum, which European settlers accepted as currency for decades. (Fred R. Woolcott Photographic Collection, Liverpool Public Library.)

This 1936 marker, posted in Seaford near Long Island's South Shore, commemorates both Capt. John Seaman, an early British settler in Hempstead, and the Marsapeag (Massapequa). It reads, in part, "Indian Trail and Seaman's Neck Path through tract purchased from Massapequa Indians, 1664, by Captain John Seaman." Tackapousha's lengthy efforts to balance the British expansion with the rights and needs of native groups can be read between the lines. (NC.)

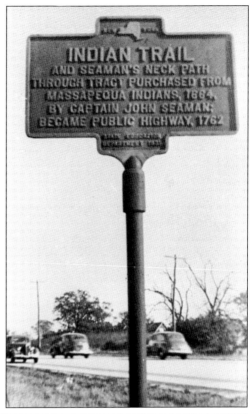

Sammis Tavern stood at an early crossroads (present-day Main Street and Fulton Avenue). Nehemiah Sammis and family came from England to Hempstead in 1650. His son and namesake built the tavern in 1660 or 1680. Graced with elegant woodwork, offering stables, lodging, and fresh meals at the hands of capable slaves (later freemen), the tavern was managed by Sammis descendants until it was moved in 1919, then demolished in 1929.

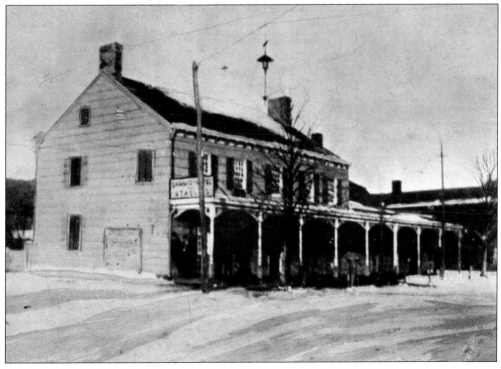

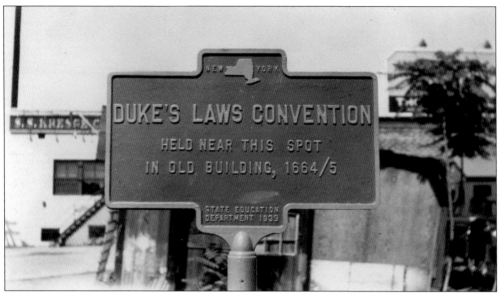

Initially, English settlement on western Long Island was politically under Holland. After war with Holland, Great Britain took control. In 1664–1665, as this 1939 marker commemorates, representatives of the Long Island settlements gathered in Hempstead to meet their new governor, Richard Nicolls. He established a uniform code law, basically an early constitution, and named it "the Duke's law" to honor Prince James of England (Duke of York and Albany).

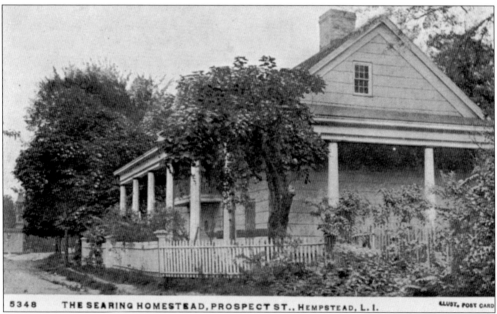

5348 THE SEARING HOMESTEAD, PROSPECT ST., HEMPSTEAD, L. I. ILLUST. POST CARD

Simon Searing, another Hempstead founder, was (like John Carman) born in Hemel-Hempstead near London. He followed Richard Denton from England to Long Island. The gracious bearing of the 1683 Searing Homestead, located on Prospect Street, is captured in this early 1900s photograph, shortly before it was taken down. Prospect School was built on its site in 1906. Simon's numerous descendants inherited Searingtown, his farming estate several miles northwest. (NC.)

This 1890 photograph of an Old Westbury farm in the Town of Hempstead shows hired black workers harvesting corn—as slaves did 250 years before. Dutch settlers imported African slaves to Manhattan in 1626. About 40 percent of Long Island farmers owned slaves, usually two or three. A 1720 census of the area now known as the Town of Hempstead counted 1,901 white adults and children and 319 slaves. (NC.)

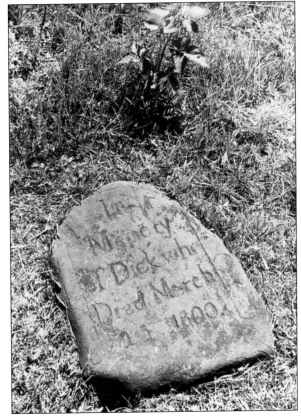

A gravestone on Gardiner's Island off Long Island's northern coast commemorates a slave's death in 1800. Long Island slaves often had quarters in the home of their owners. They farmed side-by-side with both their masters and hired freemen (white, black, or Native American), and performed skilled work in whaling and tailoring. Periodic revolts, brutally suppressed, exposed the slaves' misery; but many owners, like the Sammises, treated their slaves well.

Sometimes slaves were housed on their owners' property in small structures like "The Little House," likely built in 1764. It stood near today's intersection of Henry Street and Peninsula Boulevard, then was moved to Washington and Front Streets. William D. Meisser Jr. bought it in 1957 and moved it to Bellerose, Queens, to become the museum pictured in this 1965 photograph. Slavery in New York State ended July 4, 1827. (NC.)

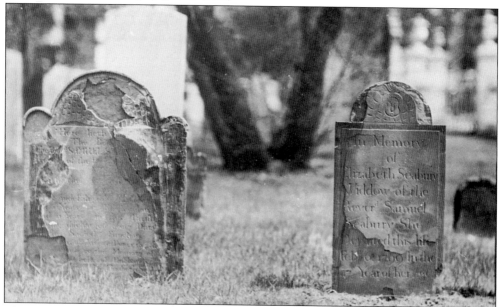

These ancient gravesites outside St. George's Episcopal Church reflect Hempstead history. The 1648 meetinghouse was sold to another Hempstead founder, Richard Gildersleeve, and a new one erected in 1673 for Rev. Jeremy Hubbard, who left in 1694. Hempstead's citizens requested a Presbyterian replacement, but Rev. John Thomas in 1702 established an Anglican congregation—St. George's. Rev. Samuel Seabury was rector 1743–1764; his and his wife's gravestones still stand.

Rev. Samuel Seabury's son, the Right Reverend Samuel Seabury, pictured in this engraving by 19th-century artist William Sharp after American portraitist Thomas S. Duché's 1786 oil, was the first US Episcopal bishop. Seabury descendants were prominent in the village for the next 200 years. Dr. Adam Seabury, another son of Samuel Seabury Sr., served Hempstead Village and surrounding areas as a physician. (Museum of Fine Arts Boston.)

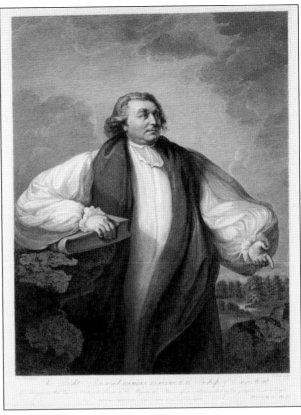

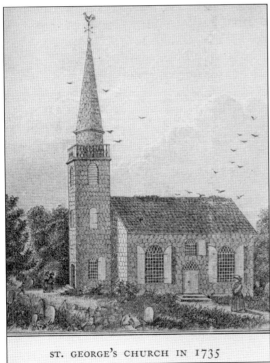

ST. GEORGE'S CHURCH IN 1735

After 1702, Hempstead's Presbyterian adherents raised their own building and became Christ's First Presbyterian Church. Meanwhile, St. George's replaced the 1673 meetinghouse in 1734 with the structure pictured here. Even today, the churchyard has gravestones dating back to 1727. When the Revolutionary War ended (1783), white tape erased prayers for King George III in St. George's prayer book. Later prayer books prayed for the US president.

19

The Rectory of St. George's Episcopal Church overlooks Peninsula Boulevard at Greenwich Street. The original parsonage constructed for Richard Denton around 1648 was replaced in 1682. For 20 more years, subsequent pastors preached to a multidenominational group. In 1702, the 1682 parsonage became a Church of England rectory. In 1793, it was replaced by this still-functioning structure; the upright supports in its basement are tree trunks, and its crossbeams are hand-hewn.

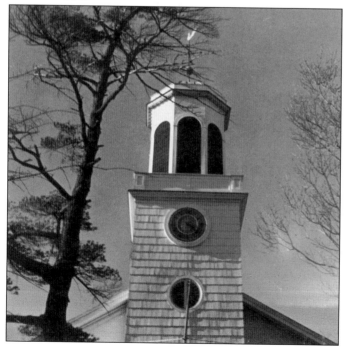

The steeple of St. George's Episcopal Church (319 Front Street) bears "The Golden Weathercock," installed in 1725 and transferred to the 1734 and 1822 church buildings. Hempstead's inhabitants were mostly Tories who opposed the Revolutionary War. Continental (American) soldiers fighting England occupied St. George's in 1782 and used the weathercock for target practice, leaving 16 still-visible bullet holes.

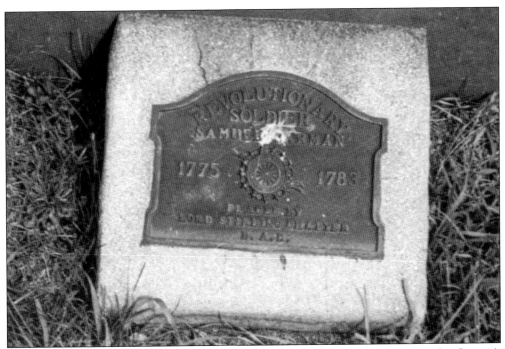

This marker, placed on the no-longer-extant tombstone of Samuel Carman in St. George's churchyard by the Daughters of the American Revolution (Lord Stirling Chapter), commemorates Carman's service in the Continental (American) Army, 1775–1783. Samuel was the son of Benjamin Carman and Mary Bedell, descendants of John Carman and Robert Bedell, reflecting the persisting linkage among Hempstead's founding families.

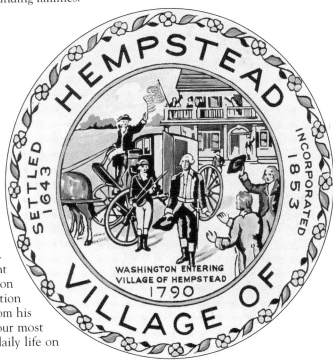

Sammis Tavern hosted George Washington in 1790 during his trip eastward across Long Island. The seal of the Village of Hempstead displays Washington with Sammis Tavern in the background. Newly elected the first president of the United States, Washington dedicatedly gathered information about his nation. His notes from his Long Island journey give us our most complete information about daily life on Long Island in the late 1700s.

The Carman-Irish House at 160 Marvin Avenue is thought to have been built by a Mr. Nelson around 1700. Nelson sold it to Mr. Tillinghast Irish. Samuel Carman (possibly the Revolutionary War veteran) bought it, and by 1840, it was owned by David Sammis. Henry Irish regained family ownership during the Civil War; his heirs, around 1940, deeded it to American Legion Post No. 390, where it hosts community events to this day.

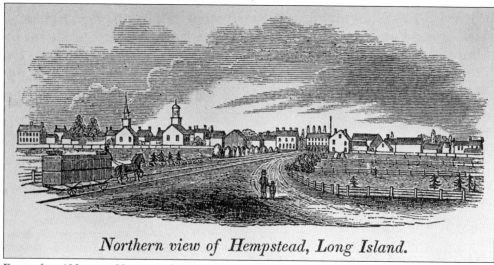

Northern view of Hempstead, Long Island.

For its first 180 years, Hempstead Village, shown about 1800, served Hempstead Town more for meeting than dwelling. Residents within the village were mainly the poor who could not farm: orphans, elderly, citizens crippled by disease and accidents, black and Indian women who had suffered loss and hardship. Hempstead developed a system for placing poor persons on farms, funding the homeowner to board the person for a year at a time. (NC.)

Two

PURPOSEFUL PROGRESS AND INCORPORATION

1800–1870

Hempstead Village and its immediate surroundings, equipped with plentiful ponds and streams, were ideal for building mills to process flour (grist), paper, and wood to supply the town's increasing population. Mill owners had to be certified by the Town of Hempstead. Founding family descendants Gideon Nichols and his brother William owned this grist mill, depicted by American artist John Evers in this 1870 painting. (NC.)

This eight-room dwelling housed renowned American inventor Peter Cooper and his wife, Sarah Bedell Cooper, 1814–1818. Bought from William and Gideon Nichols, at least one room was likely pre-1700. It stood on the east side of Clinton Street in Hempstead until it was moved to its present, permanent location in Old Bethpage Restoration Village, where visitors are guided through to enjoy the flavor of Hempstead's early residential life. (NC.)

Peter Cooper, shown in this 1880 photograph at age 88, spent his life inventing products that varied from powdered gelatin and much-improved glue, to a tiny steam engine called Tom Thumb, to cables such as those that eventually supported the Brooklyn Bridge. In 1859, he formed The Cooper Union for the Advancement of Science and Art, an admission-free school for adults, in Manhattan; it remains a renowned institution. (NC.)

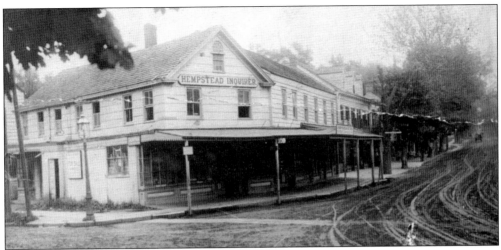

In 1830, Hempstead's first newspaper opened with the lengthy title *Long Island Telegraph and General Advertiser.* In 1831, it became the *Hempstead Inquirer,* one of several weekly papers in Nassau County that James E. Stiles consolidated in the early 1930s to form the *Nassau Daily Review.* Its building at the southeast corner of Greenwich and Front Streets is pictured here.

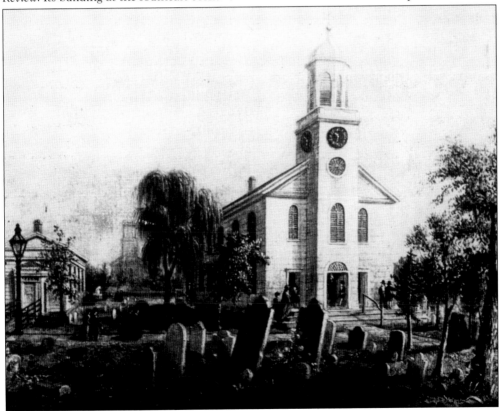

By 1800, the United States had its own Episcopal bishop (Samuel Seabury Jr.). Now new priests did not have to sail to England for ordination. Clergy were therefore more available, strengthening St. George's. This 19th-century painting displays the still-standing St. George's building that replaced the 1734 church after it burned in 1820.

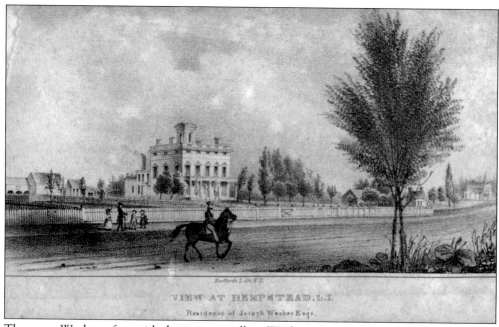

Sarah Clowes transfers power of attorney to James Tidbury in this 1832 document. Gerhardus Clowes was a Hempstead founder whose descendants lived in the village for more than 300 years and spread across Long Island. The name "Clowes" appears in records of St. George's, as well as Christ's First Presbyterian Church. Intermarriage among founding families strengthened Long Island's financial and political development. (East Hampton Library, Long Island Collection.)

VIEW AT HEMPSTEAD, L.I.
Residence of Joseph Weekes Esqr.

The name Weekes, often with the variant spelling Weeks, appears in town, village, and church records throughout Long Island but particularly frequently in Hempstead during the first 200 years after English settlers arrived. Joseph Weekes was the owner of this grand residence, according to this 1840s drawing. His property stood at the western edge of the village and exemplified the grand vision of the village's prominent residents.

Lowden's Pond (formerly Raynor's Pond), shown here in 1919, was among the many bodies of water supporting agriculture on Hempstead Plains. It once stood at present-day Clinton Street and Fulton Avenue. The livestock that drank there were decimated in the Revolutionary War by first the British and then the Continental Army. Subsequently, the waterways nurtured smaller farms with grand houses like that of Joseph Weekes, and provided recreation.

Peter Treadwell's house on Clinton Street held the first meetings of the African Methodist Episcopal Zion Church in 1840. New York State abolished slavery within its borders in 1827, but the new equality for African Americans did not result in immediate integration, and Hempstead's significant black population needed worship space. Treadwell, a village citizen, offered his house on Sunday nights. The congregation soon erected its own building.

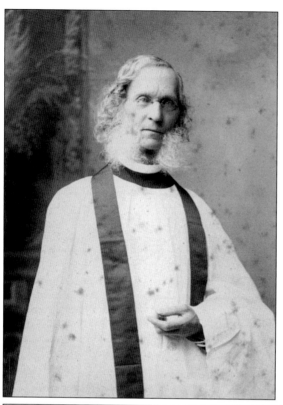

William H. Moore, rector of St. George's Episcopal Church from 1849 to 1892, wrote a history of St. George's that supplied important historical details of the Hempstead area. Lists of vestry members throughout the 250 years of Hempstead's existence until Moore's death reveal the ongoing names of founding families: Bedell, Clowes, Sammis, Weekes, Carman, Denton, Snedeker, Treadwell, Hewlett, Kissam, Gildersleeve, Seabury, Onderdonk, Smith, and Cornell.

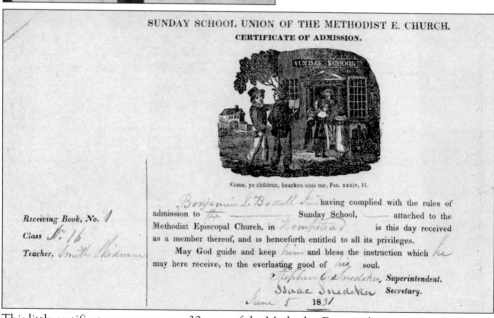

This little certificate represents over 30 years of the Methodist Episcopal presence in Hempstead Village. In 1830, the first Sunday school was established with 12 teachers and 37 scholars. In 1834, the parsonage was built on the same lot. Isaac Snedeker, descendant of a longstanding Hempstead family, was secretary; Stephen C. Snedeker, owner of S.C. Snedeker & Co., was superintendent of Sunday school.

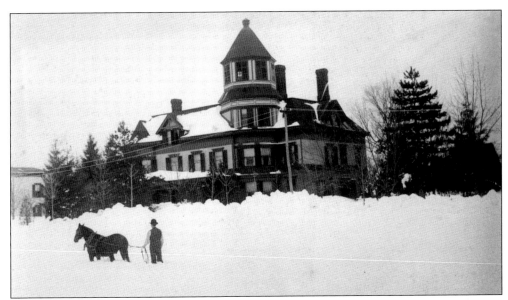

Benjamin Franklin Thompson occupied this house on Fulton Street near Terrace Avenue (shown here years after, towering above the drifts of the Blizzard of 1888). Born May 15, 1784, on a Setauket farm, Thompson became a physician and New York State assemblyman. He helped found the first Setauket public library. In 1818, he left medicine to practice law and, in 1824, moved to Hempstead with his wife and two sons.

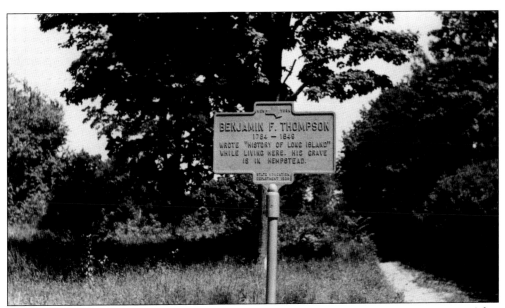

Benjamin F. Thompson (1784–1849) was appointed district attorney for Queens County. After extensive reading, traveling to view parts of Long Island, studying county, town, and state records, and interviewing many people, he produced his three-volume book, *The History of Long Island: From Its Discovery and Settlement, to the Present Time*, in 1843. This marker in his honor has stood on Front Street, across from Hempstead Town Hall, since 1939.

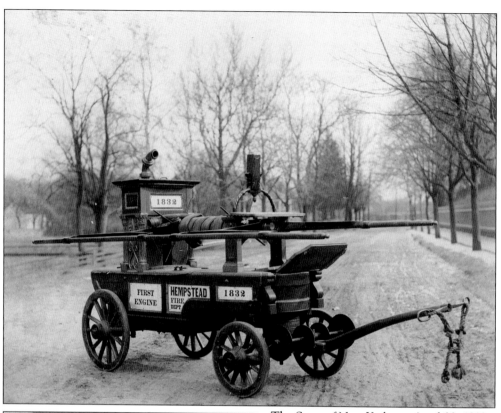

The State of New York, on April 23, 1832, passed "an Act to authorize the formation of fire companies." The Hempstead Town government appointed firemen to the Village of Hempstead. This 1832 fire engine replaced bucket brigades. Pulled by the firemen themselves, it could suction water from a water source and pump water through the hose onto the fire, enhancing the safety of the men trying to extinguish the flames.

These December 15, 1832, signatures of the newly appointed firemen included names reaching back to Hempstead's first century: Stephen Hewlett, Joseph D. Gildersleeve, Latten Smith, Thomas D. Carman, Isaac Snedeker, Joseph B. Gildersleeve, Charles Baldwin, Jarvis Bedell—those who would step forward to do what was needed, paid or unpaid. Except for one paid fireman in the early 1920s, Hempstead's firefighters have always been volunteers. (Town of Hempstead.)

From Josiah Gildersleeve in 1835, this home at 20 North Franklin Street passed to his great-granddaughter Jessie Duryea. It was used 1939–1942 by the Hempstead Village Police Boys' Club. In 1948, the Lord Stirling Chapter of the Daughters of the American Revolution moved it opposite Village Hall for use as a museum. It received a new address: 1776 Denton Green. It is now occupied by the Hempstead Chamber of Commerce.

This 1850 schoolhouse once stood at the corner of Henry Street and Prospect Street (since renamed Peninsula Boulevard; the name "Prospect Place" was assigned to a small street nearby). Although Hempstead collected taxes to educate "poore orphants or other poore inhabitants' children" as early as 1658, families and clergy usually educated the young children of early Hempstead. An 1838 New York State charter granted the village a public school.

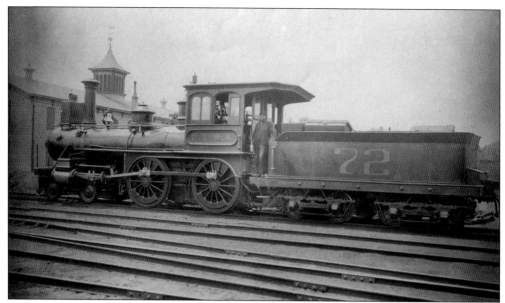

The first Long Island Railroad engine, steam-powered old No. 72, stands on the tracks. The LIRR was started with the support of Cornelius "Commodore" Vanderbilt in 1834, not to serve Long Island's residents, but to carry rich passengers across the island's length. In 1839, the Hempstead branch was completed, with tracks running from Mineola down Main Street to S.C. Snedeker & Co. on Front Street.

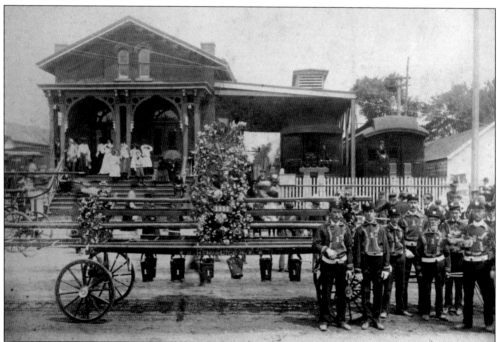

This Long Island Railroad station, with the South Hempstead Hook and Ladder No. 1 Fire Department posed in front, depicts one of several locations to which the station was moved. By the time this photograph was taken, early 1900s, the station had been moved to Fulton, east of Main, next to then-Christ's First Presbyterian Church.

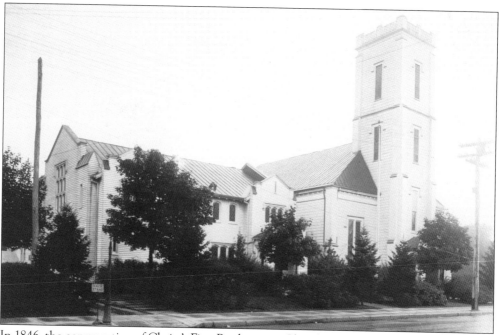

In 1846, the congregation of Christ's First Presbyterian Church erected this gracious building on Fulton Street at the eastern end of now-Denton Green (then the community graveyard). They sealed a foot-long lead box, unopened until 1968, into the cornerstone. It contained maps, an 1845 Bible, and local statistics, noting that in 1845, Oyster Bay had 19 taverns, while Hempstead had 37—an issue of natural concern to church citizenry.

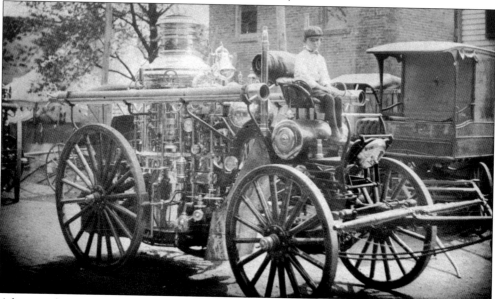

A boy perches atop a horse-drawn fire engine. By the time of incorporation in 1853, horse-drawn engines dominated the firefighting scene, and continued to do so until the 1920s. Subsequently, combining a gas-powered engine with firefighting equipment became the norm. Firefighting technology also continued to advance the structure of hoses for conducting water to flames, developing firefighting garments, and creating safe, fireproof ladders.

Sam Williams, who moved to Hempstead Village in 1900, is being included here to represent the reality of African Americans' ongoing presence in the village throughout its history. Williams lived in the tenant house on the Hicks farm in Old Westbury, doing dairy work. When the Hicks barn burned in 1900, he found a home in Hempstead Village, probably along western Front Street.

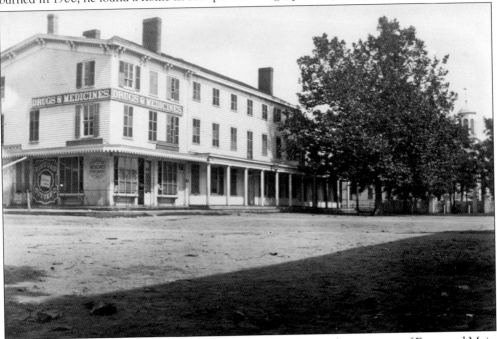

On Monday, July 25, 1853, in Stephen Hewlett's hotel at the northeast corner of Front and Main Streets (pictured), villagers voted 88 to 41 for incorporation. In New York State, an incorporated municipality is granted Home Rule: the right to exercise self-government over local affairs. With a population of about 2,000, the village felt ready to make decisions regarding its own roads, quality of life, commerce, and maintenance.

Hempstead Village's first president—the term *mayor* was not used until 1927—was John Augustus Bedell, 1831–1894, son of Stephen Carman Bedell. He was 22 when the board of trustees appointed him. The trustees had been elected by the villagers on August 22, 1853; choosing the village president by popular election came in 1895. Bedell's house on Greenwich Street (pictured; later demolished) passed to a relative, Maude Augusta Wright.

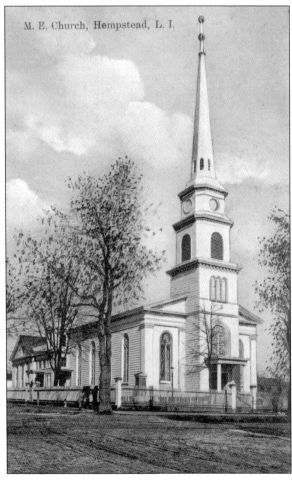

M. E. Church, Hempstead, L. I.

By 1854, the Methodist Episcopal Church had 190 members. Church and parsonage were sold to construct the present building, dedicated June 30, 1855. A Sunday school building was added to the north of the church in 1866, expanding in 1895 and again in the 1960s. The church spire is the tallest in the village and one of the tallest in Nassau County. (Town of Hempstead.)

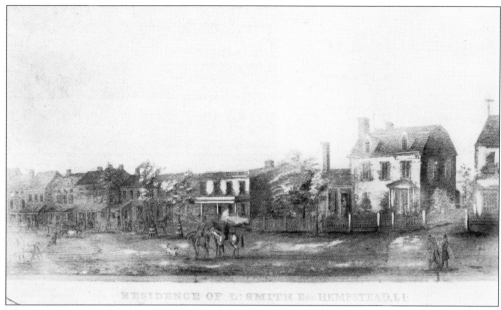

This ancient, scratchy representation of the west side of Main Street between Fulton and Front Streets in 1856 displays large, closely set wood frame houses. Quite often, a professional's business (doctor, lawyer, realtor, photographer, printer) was conducted in one part of the person's residence. Larger concerns such as Hewlett's Hotel or S.C. Snedeker & Co. general store often were owned by persons with several parcels of property in and bordering the village.

This home at Jackson and Fulton Streets belonged to Thomas Henry Clowes (1819–1905). He operated an insurance business with his son Benjamin Valentine Clowes, a justice of the peace and the first popularly elected village president. A street commissioner in the newly incorporated village, T.H. Clowes became secretary of the Jamaica and Hempstead Plank Road Company, which built trolley lines. His death certificate listed his occupation as "gentleman."

Lifelong village resident Lott Van De Water Jr. started the *Queens County Sentinel* with John Hentz in 1858. It became the *Hempstead Sentinel* when Nassau County formed, on January 1, 1899. He also served 30 years with the Queens County Agricultural Society, 23 years as Hempstead Village clerk, 30 years as clerk of St. George's Episcopal Church, and in leadership of the Odd Fellows and the Masons, Morton Lodge No. 63. (NC.)

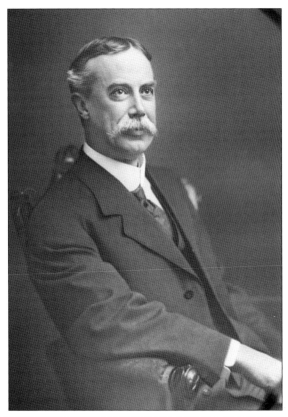

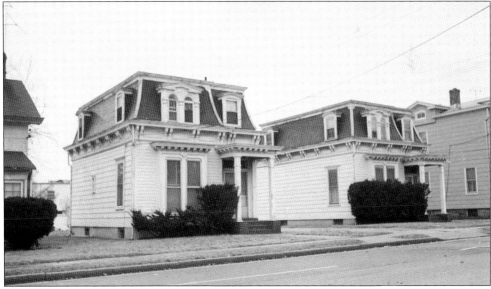

Nos. 54 and 56 Orchard Street, two prime examples of Victorian architecture built 1868, stood originally on Alden Place near the Calderone Theatre on North Franklin Street. They were moved to their present location in 1946. In 1947, as World War II veterans returned from Europe, No. 54 was modified to become a two-family unit. The homes are of clapboard with brick porches and fish-scale or "mansard style" slate roofs.

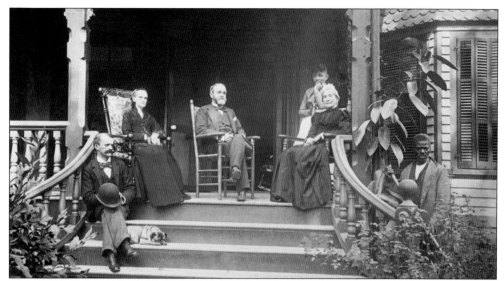

Rev. Samuel Seabury's descendants were core to Hempstead's business and social structure. Seated on the steps of Adam Seabury's Star Cottage in 1890 are his brother Charles (a realtor), Elizabeth Hentz (their mother), Adam (New York banker and senior warden of St. George's Episcopal Church), and unidentified individuals. Not pictured are John, a New York merchant, Robert, an attorney and cofounder of Hempstead Bank; Samuel, a realtor; and Albert (deceased). (NC.)

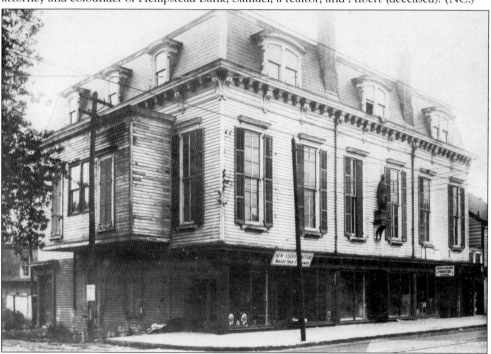

Liberty Hall arose in 1868 across Front Street from St. George's. Its ballroom and theater accommodated social events and advertised famed New York performers such as Edwin Booth. Hempstead's first Jewish minyan gathered there in 1907, becoming Hempstead Hebrew Congregation in 1915 (today's Congregation Beth Israel). Later, it was used for clubs, apartments, and small businesses. The Town of Hempstead replaced it in 1968 with additions to Town Hall.

A.T. Stewart (1803–1876) built a New York City clothing empire and supplied uniforms to the US military during the Civil War. In 1869, he bought 7,000 acres on Hempstead Village's northern border. His planned community, Garden City, included working-class homes, but also the immense Garden City Hotel, a gathering spot for socialites. Hempstead's well-developed services helped supply Garden City as it burgeoned. (Garden City Public Library.)

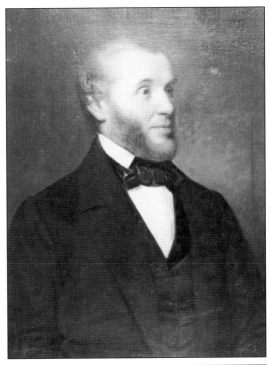

This sketch, probably a study by American artist John Evers (1797–1884) for his 1869 painting of the same scene, depicts Main and Front Streets. At that time, Main Street dead-ended into this commercially active green. Later, Little Main Street was constructed slightly to the east of Main Street, connecting Front Street with Prospect Street a block to the south. Hempstead was becoming renowned for its scenic homes and businesses.

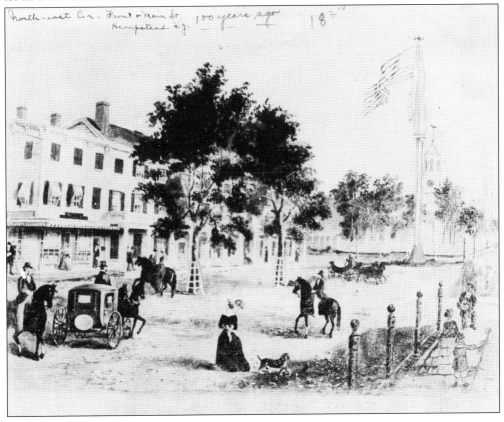

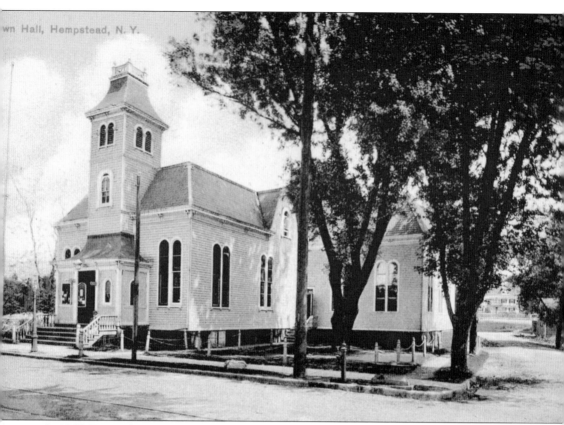

In 1867, Town of Hempstead officials offered the Ladies Washington Sewing Society "the green and public grounds in front of the Episcopal church" for building a village hall. This society, also known as Ladies Washington Association, was not for casual get-togethers; in accord with a Special Act of the Legislature of the State of New York, it was a corporate association capable of acquiring property. The society built Washington Hall in 1870, facing St. George's across Front Street, with Liberty Hall across Liberty Street on its west side. Rather than becoming the village hall, it was used for social events and annual town meetings. In 1874, the Town of Hempstead bought it to become Hempstead Town Hall. By 1918, space demanded construction of the current town hall on the land adjacent to the east. (Town of Hempstead.)

Three
NEW YORK'S PLAYGROUND
1870–1900

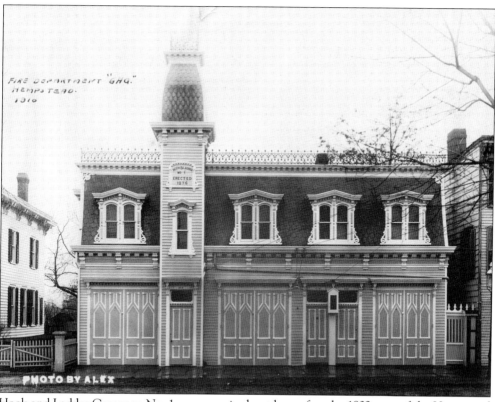

Hook and Ladder Company No. 1 was organized not long after the 1832 start of the Hempstead Fire Department. Between 1873 and 1876, this elaborate building on Cross Street (shown in 1910) was created to house the company and serve as the Hempstead Fire Department headquarters. In May 1877, it became the Harper Hook and Ladder Company No. 1. In 1956, the creation of Peninsula Boulevard necessitated its removal.

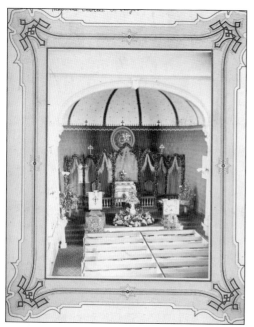

St. George's Episcopal Church (shown in 1873) chose elaborate decorations to honor Easter. Since then, wall plaques have been added inside commemorating rectors and dedicated church members. Remodeling has added classroom space. A 1920 two-thousand-pipe organ undergirds its hymns at services. Many of the 1943 ceremonies celebrating Hempstead Village's 300th anniversary occurred here. St. George's ongoing ministries include Boy Scouts and a weekly soup kitchen. Its 1822 oak beams still support its walls.

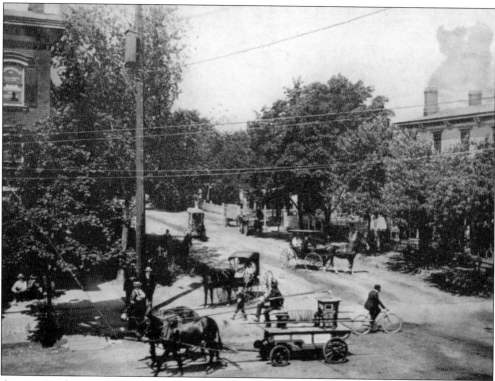

As seen in this 1876 photograph, Hempstead Village developed into the first shopping center east of Jamaica in then–Queens County. Philip Harper, son of James Harper (the publisher who founded Harper and Brothers), had a mansion in town. S.C. Snedeker & Co. on Front Street presaged later department stores, and Isaac Snedeker's substantial 1810 house, address 359 Front Street, exemplified the village's connection to both past and future.

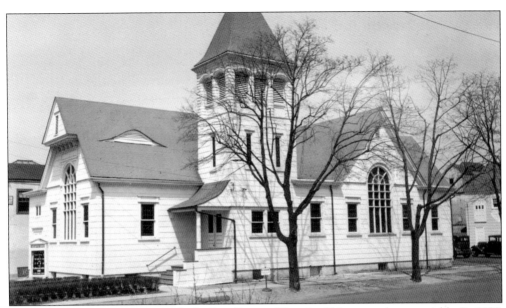

From its 1883 start in Liberty Hall, the First Baptist Church of Hempstead grew quickly. By 1889, its 57 members laid the cornerstone of the building pictured here, which stood until 1949. By 1925, the congregation numbered 137. Across the decades, First Baptist's support for Hempstead's African American population eventually led to help organizing Hempstead's Union Baptist Church, whose current pastor is Rev. Sedgwick Easley.

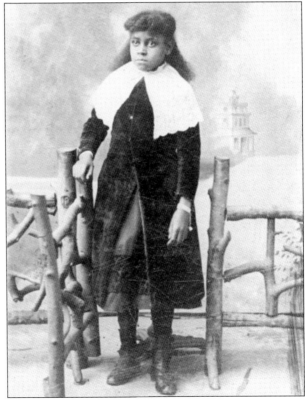

This photograph demonstrates, once again, the importance of family stability and tradition in the building of a community. Irma Brasier was born in 1904. Her maternal grandmother was Julia Herod, who married Anthony Brasier and gave birth to Walter Brasier, Irma's father. Herod preserved this 1885 photograph of Irma Brasier's mother, Louisa Valentine, at age eight. Walter and Louisa settled in Hempstead, where they raised Irma and her brothers, Russell and Valentine.

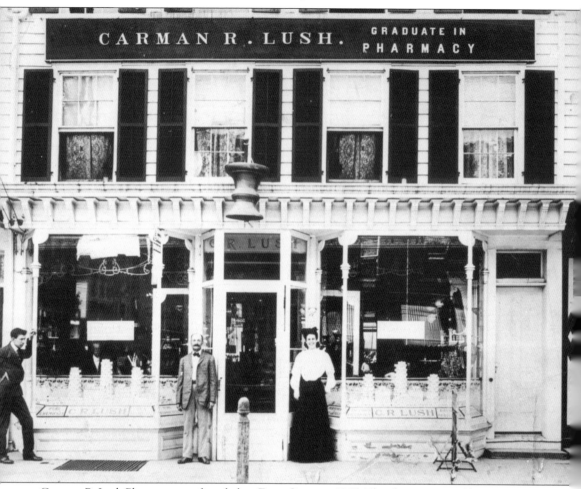

Carman R. Lush Pharmacy was founded on Front Street in 1885. The pharmaceutical business was then transitioning from on-premise pill mixing by apothecaries and apprentices to college-trained pharmacists dispensing medications under established standards—with sodas and sandwiches to add neighborliness. Carman R. Lush stands to the left of the door. Two Hempstead founding families plus another English family are represented by him. His grandfather, James Lush, came from Somerset, England, and married Mary Carman of Hempstead. From them, on September 23, 1813, Carman Lush was born and subsequently married Mary Elizabeth Bedell. Mary died in 1841 soon after delivering her third baby, James Lush. Carman then married Catherine A. Weeks, who bore Mary Elizabeth Lush and, in 1859, Carman R. Lush. After founding his pharmacy, Carman R. was active in community affairs for another 60 years.

Philip Harper's 1859 mansion on Prospect Street occupied the grounds of today's Alverta B. Gray Shultz Middle School. A Methodist Church trustee and treasurer of Morton Lodge No. 63 for 25 years, Harper served nine terms as village trustee and was president twice. He built and donated five firehouses, exemplifying the wealthy, civic-minded citizens of the Hempstead community. This house stood until 1939.

Philip Harper married Augusta Thorne, youngest sister of his stepmother Julia Thorne Harper. Julia owned property near Philip's. When she died, the left it to Augusta, who deeded it for park land to Hempstead Village in 1911 for $100. The park was completed by 1913. The May 1913 issue of *Hempstead Topics* contained an article titled "Hempstead Is a Panorama of Beautiful Lakes and Gardens"—one being Harper Park.

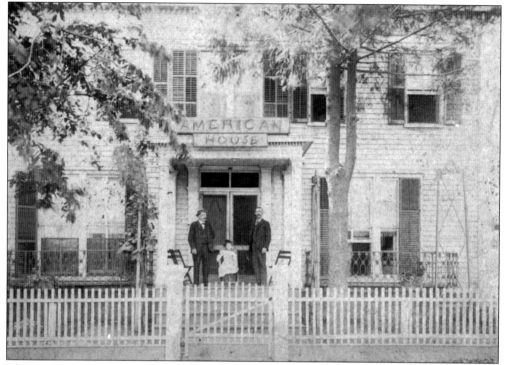

The American House, a boarding house run by Mrs. Kelly (first name unknown), stood on Fulton Avenue opposite the Long Island Railroad Station, 1880–1895. American boardinghouses typically were run by no-nonsense middle-aged widows. Substantial meals were served at a common table—arrive punctually or go hungry. Customers were usually single people, often young men coming from farms to see city work, commuting on the LIRR.

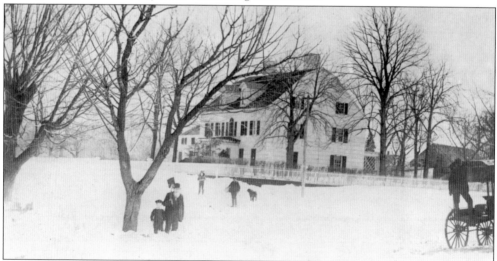

Like St. George's itself, the 1793 rectory has been a landmark frequently used as a background for Hempstead photographs. The busy yet spacious community proved an inviting location to well-off business folk, while providing employment opportunities for those in service-oriented occupations such as hotels, stores, and fuel supply. The sense of community is evidenced by the shovels in the hands of people clearing the snowy roadway.

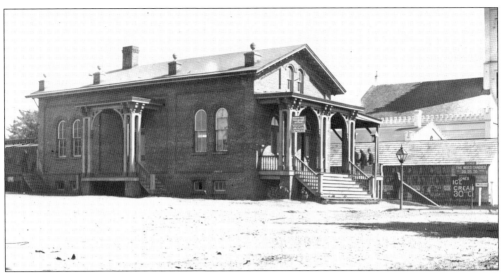

The 1872 Fulton Avenue Long Island Railroad Station stands at left with Christ's First Presbyterian Church partly visible at right. The station was used until 1913. In 1894, Christ's First Presbyterian stood out for allowing a women's suffrage meeting, led by Anna Willets of the Queens County Committee, which proved that 1,200 Town of Hempstead women were paying taxes and, therefore, should have the right to vote. (NC.)

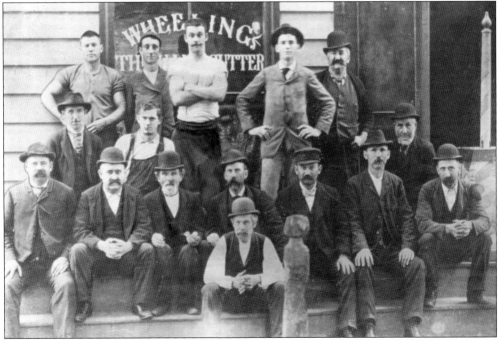

Wheeling's Barber Shop on Greenwich in 1890, like many barbershops, provided a gathering place where men swapped news and talked business. Pictured are Selah B. Payne, Jacob Sprague, Nelson H. Duryea, Joseph Adams, Henry E. Ackley (of Pflug & Ackley, a Hempstead bottling works firm), Tredwell Elderd, Neal Duryea, George Washington Beckhorn, Jolin O'Hara, William Sprague, John Gardner, John Matthews, Richard Matthews, Mahlon Cornelius, and George Wheeling. (NC.)

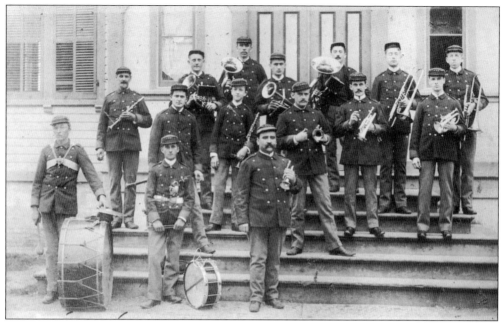

Hempstead Village had its own brass band featuring well-known citizens. Pictured from left to right are (first row) William Wright, Fred Schoen, and bandleader Cyril L'Africain; (second row) Jones Lewis, Julius Bloom, Eugene P. Parsons, Fred Gildersleeve, George H. Baukney, and Robert S. Powell; (third row) J.T. Baukney, John Bairn, William B. Van Sicklen, Eugene Raynor, Glen C. Pettit, and E.V. Baldwin.

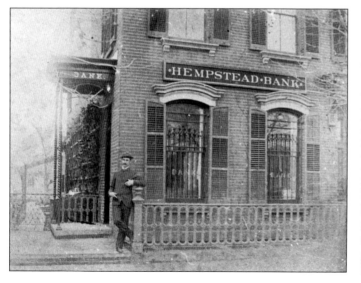

Hempstead Bank, the village's first, opened in 1887 on an upstairs floor of the Samuel Seabury Building at the southwest corner of Main and Fulton Streets. Martin V. Wood was its first president. Hempstead's population had grown beyond 2,000. Samuel Seabury, realtor and insurance businessman, stands beside his building in this 1890 photograph. Hempstead continued expanding not just as a commercial hub but as a societal one.

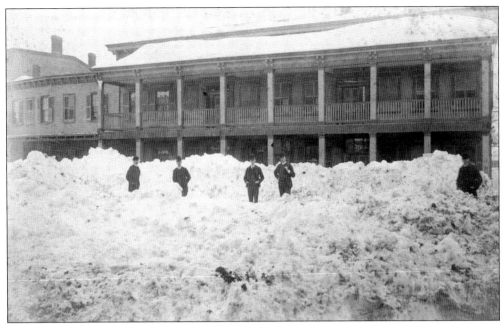

These men in front of Hempstead's Occidental Hotel had just endured a titanic snowstorm. Commonly known as the Great Blizzard of 1888, the storm assaulted the Eastern Coast, March 11–14, dropping 40 inches on the New Jersey–New York–Long Island area. The hotel exemplifies the village's growing service economy, and would have given refuge to people unable, for days, to travel by rail or communicate via phone and telegraph.

Half a block south of Matthews' Hotel, at the northeast corner of Front and Main Streets, another group of men confronts intimidating snowdrifts. Visible are telegraph poles and wires. This March 1888 blizzard provided impetus for telephone and telegraph companies to start burying power lines underground. Electrification had only just arrived in Hempstead in 1886; subsurface power lines came later.

On April 1, 1879, John R. Bedell and E.L. Pray joined forces to establish Bedell and Pray, a meat shop and a Hempstead mainstay for decades. Bedell passed away before 1907, at which time Pray and Co. existed at 298 Front Street. Pray celebrated his 82nd birthday in 1929, having worked 68 years without vacations from either his youthful work as a delivery boy or his meat business.

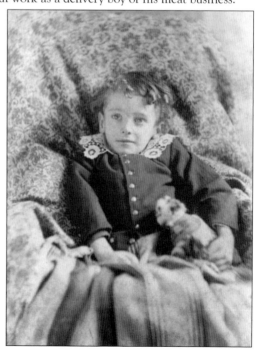

The oldest of Robert and Elizabeth Seabury's six surviving sons, Albert Hentz Seabury, married Eliza Cowenhowen Place on November 7, 1872. They bore Fredrick Charles Seabury, on July 8, 1875; Elizabeth Seabury, on December 21, 1877; and William Ham Seabury, on August 21, 1881. As happened all too often in those times, William, affectionately positioned here for a final photograph, contracted a childhood illness and died on May 24, 1886.

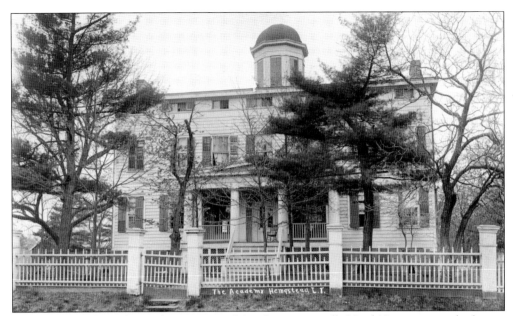

The Long Island Academy, also Hempstead Academy, originally Hinds' Institute, was built on a corner of High and Orchard Streets near the center of the village in 1836. Historian Benjamin F. Thompson, in 1848, called it the "crowning ornament of Hempstead." Chartered by New York State in 1838, it struggled 25 years on public support and subsequently went private. Elizabeth and Frederick Seabury were educated there. It stood until 1917.

In 1887, Hempstead Village had upscale residences, businesses, banks, a railroad station, five churches, two schools, two halls, a quantity of boardinghouses, and six hotels. This September 18, 1891, parade of the Hempstead Fire Department along Front Street, picturing Chief Edward Cooper next to state-of-the-art firefighting apparatus decorated with flags and bunting, captures the village's sense of growth and strength.

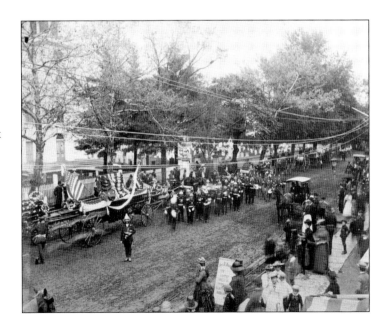

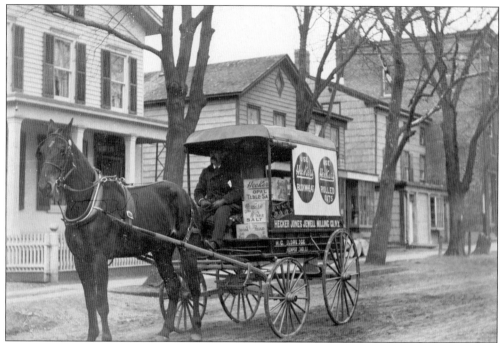

Henry C. Eldredge sits in his horse-drawn wagon on Front Street, west of Main Street. Eldredge exemplifies a businessman's savvy, using his delivery wagon to advertise Hecker Jones Jewell Milling Co., a merger of three major mills near New York City. Daily deliveries created and maintained the village's reputation as the major commercial center east of Jamaica, Queens.

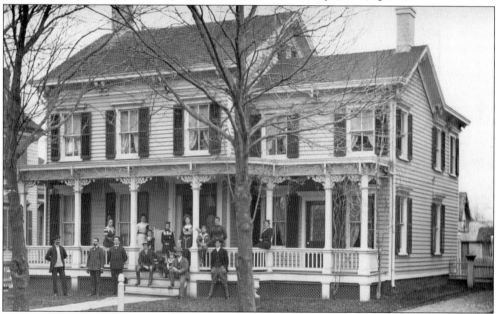

Henry Eldredge's business provided enough for him to inhabit this grand home on Washington Street, one of the village's central north–south roads. The unidentified people wear clothing typical of the late 1890s or very early 1900s. The younger folk may have been students at Hempstead Public School, which housed grades one through twelve in a building completed in 1889.

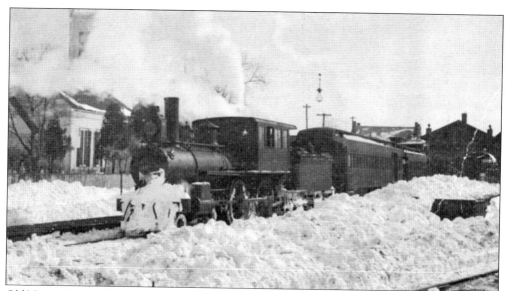

Old No. 93 Railroad Car steams out of Hempstead's Fulton Avenue Long Island Railroad Station in the 1890s. Bankrupt in 1850, the LIRR reemerged in 1851 with a charter to develop service to the north and south shores. An 1873 map shows two railroad lines into the village: New York & Hempstead Railroad, and the LIRR, which also had a freight depot at Centre and Main Streets, near two coal yards.

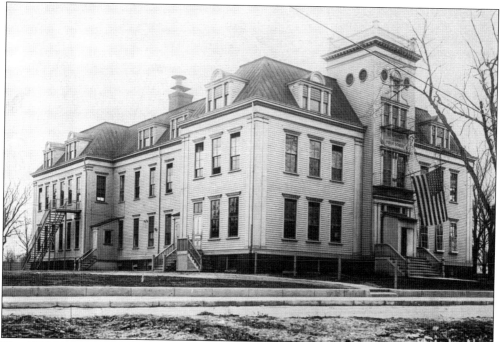

The 1889 Hempstead Public School had 25 classrooms and a gym. Initially, it served all grade levels. By 1900, the village population reached 5,000. Schools for lower grades gradually appeared; Charles Ludlum pioneered construction of smaller schools throughout the village, rather than one central building. Hempstead Public School became Hempstead High School, both for village inhabitants and for surrounding hamlets. Fire demolished it on April 5, 1919.

During the 1880s and 1890s, Hempstead acquired a German-speaking population, who judged it "a complete and competent village, providing varied facilities for its inhabitants." They needed "a church which spoke to them in a language they could understand." They started Lutheran Church of the Epiphany on January 7, 1897, meeting in King's Daughters Hall, a two-story frame house that accommodated them for nearly two years.

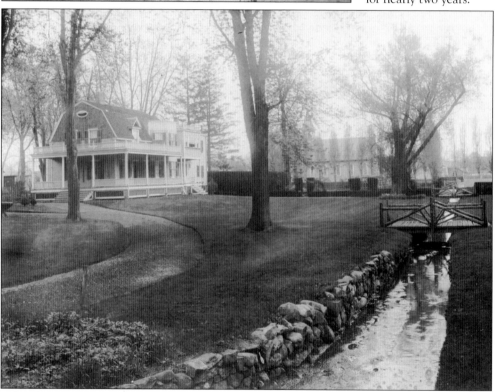

Behind the Addison Home, pictured here about 1915, stands the 1899 Lutheran Church of the Epiphany. The congregation laid its cornerstone at Franklin and Orchard Streets on October 23, 1898, and dedicated it on January 29, 1899. They had to fill in its low, swampy ground and pump water from its basement. In 1903, they purchased a parsonage, paying their parson $40 a month.

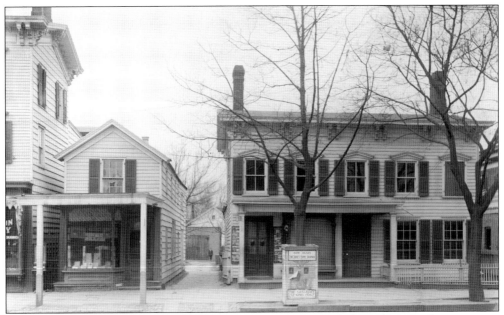

For the Village of Hempstead, Henry Agnew Stationers, seated along the main business strip of that time at 47 Main Street, provided more than paper, pens, pencils, and ink. The business also supplied postcards of Hempstead Village. From this unpretentious little store, pictures of Hempstead's charming parks, stately mansions, picket-fenced neighborhoods, proud public buildings, and dignified churches were mailed far and wide—including to soldiers in both world wars.

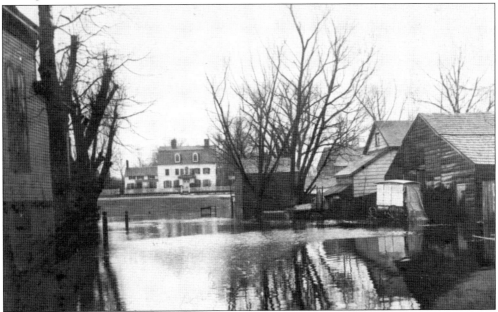

Rockaway Stream, one of Hempstead's two main brooks, flowed roughly along the current route of Peninsula Boulevard. When it overflowed, the south side of Front Street between Washington and Little Main Streets became "Ducktown," filled with water, mud, and ducks. St. George's Rectory on Prospect Street (now Peninsula Boulevard) is visible across the water. The broad pipes that would later channel Hempstead's abundant waters below ground had not yet arrived.

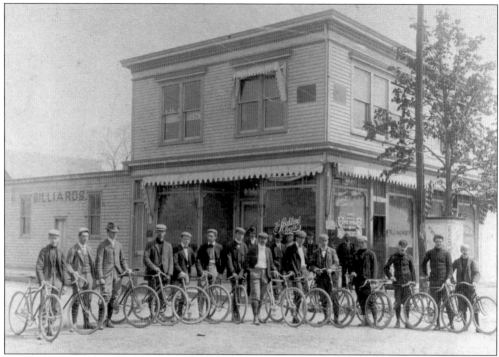

Subsequent to the development of the pneumatic bicycle tire in 1888, which made bicycle riding more comfortable and facilitated tire repairs, cycling clubs such as Hempstead Bicycle Club became the rage. A six-day workweek was the norm, so Sunday cycling club tours offered a breezy release, speeding along over unpaved roads and grassy fields. Sports stores like the one pictured behind the Hempstead Cycling Club appeared as well.

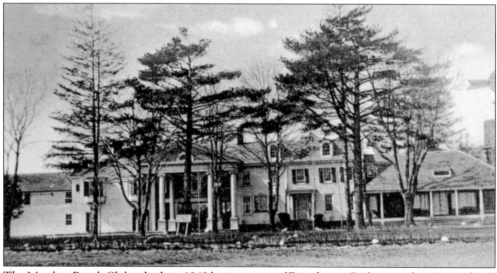

The Meadow Brook Club, which in 1949 became part of Eisenhower Park, was a favorite weekend haunt for New York City's socialites. Mr. and Mrs. James L. Kernochan, whose summer estate sat just east of the village, were prominent members and well-known in Hempstead. Athletic and charming, they led in fox hounding and polo for more than a decade, during which Long Island earned the nickname "New York's Playground." (NC.)

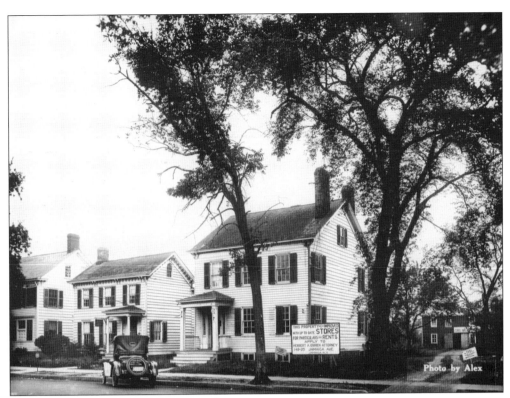

Photo by Alex

In 1889, the Hempstead Subscription Library was started by Harriet and Fanny Mulford, Julia Parsons (wife of Chauncey C. Parsons), and Mary Smith, who operated it with her sister Sarah Smith in their business building on Greenwich Street. Around 1907, the library was moved into the house in the center of this photograph at 260 Franklin Street, where it remained until 1927, and was called the Cottage Library.

Charles H. Ludlum, born February 21, 1843, obtained his MD from the University of New York in 1865. He practiced in New York and New Jersey until 1878, when he established a practice in Hempstead Village. He served as president of the Hempstead Board of Education from 1888 to 1928. In 2008, Charles H. Ludlum Elementary School on Jerusalem Avenue was renamed Barack Obama Elementary School in honor of the president-elect.

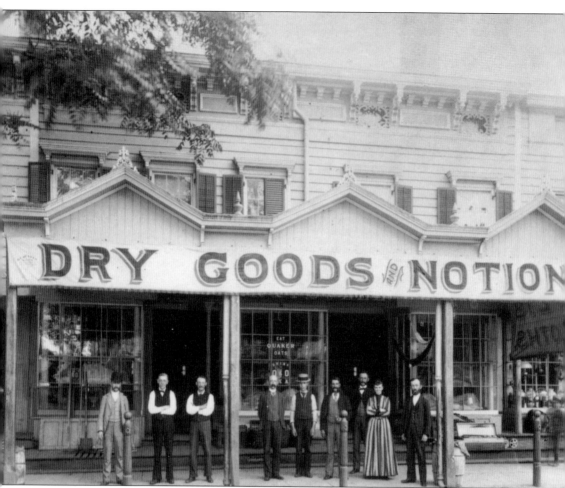

Edward Cooper, fire chief and Hempstead Bank official, with Henry Powell ran Cooper and Powell's General Store during the latter 1800s and into the 1910s. Over the door, large letters proclaimed, "Dry Goods and Notions." *Dry goods* referred to household items such as red flannel underwear, lanterns for barns, and feed bags, halters, or fly nets for horses. Milk pails, cream pans, milking stools, feed, and salt rocks could be bought for the household cow. Drivers for the store collected orders from residents each morning, then filled the orders and delivered them in the afternoon. Rich and poor swapped pleasantries at Cooper and Powell's—even Elliott Roosevelt, Eleanor's father. He owned a house on Richardson Place, where St. Ladislaus Church Rectory now stands, from the summer of 1888 to the summer of 1894, when Eleanor (October 1884–November 1962) was ages three through nine.

Louis Cohen's Department Store, Inc., at 36–38 Main Street (selling dry goods, clothing, millinery, and hosiery), attracted a well-turned-out clientele. With its bunting-decorated storefront amid cheering people, this store shows the residential appearance of many businesses of the 1800s, but the 1892 date on the building is matched by another Cohen structure that shows the changing concept of business in Hempstead.

On the east side of Main Street, Louis Cohen replaced William Stoffel's combined home and real estate business with this impressive stone structure—a "business block." It harbored a shoe store and sold larger items than the dry goods store, such as furniture and carpentry. This 1892 building presaged the replacement of wood-frame homes/businesses on Main Street, Fulton Avenue, and Front Street with stone edifices, made possible by freight-carrying railroads.

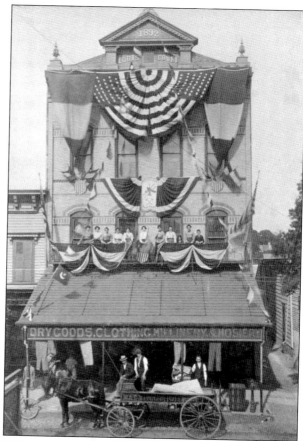

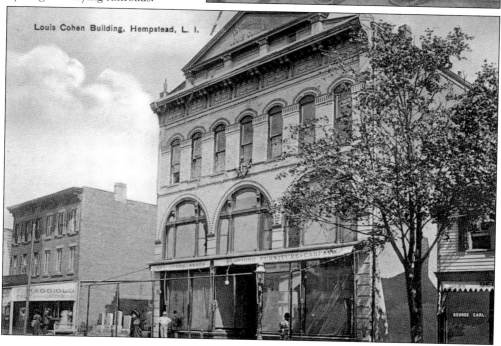

Louis Cohen Building, Hempstead, L. I.

The Odd Fellows, a fraternal organization, provided health and other insurance for its members, who performed local charitable services. Though racially segregated until 1971, it accepted members of all income levels. This 1900 photograph shows, from left to right, (first row) Harry Wincke, Al Humphries, unidentified, Dan Van Wickler and unidentified; (second row) prominent Hempstead contractor and volunteer fireman Thomas Berg, two unidentified men, and Clarence Berry.

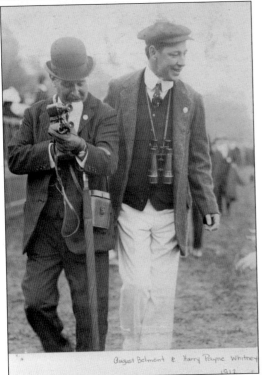

August Belmont & Harry Payne Whitney 1912

Financier August Belmont Jr. (1853–1924) is shown at left with financier friend Harry Payne Whitney. Banker August Belmont Sr., established the Belmont Stakes. August Jr. founded the New York City subway system with his Interborough Rapid Transit Company. He built Belmont racetrack and several summer estates, including one at Bennett Avenue and Fulton Street, served on the St. George's Episcopal Church vestry, and played polo at the Meadowbrook Club.

Alva Belmont (January 17, 1853–January 26, 1933), wife of August Belmont Jr.'s uncle, Oliver Hazard Perry Belmont, first married William Kissam Vanderbilt, grandson of railroad magnate Cornelius Vanderbilt. William, fascinated by both cars and women, found Alva divorcing him in 1895. In 1896, Alva married O.H.P. Belmont. She joined the American Institute of Architects, which was unusual for women then, and involved herself in designing mansions. (National Woman's Party.)

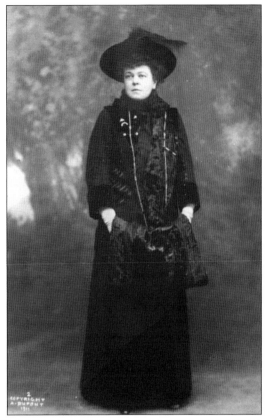

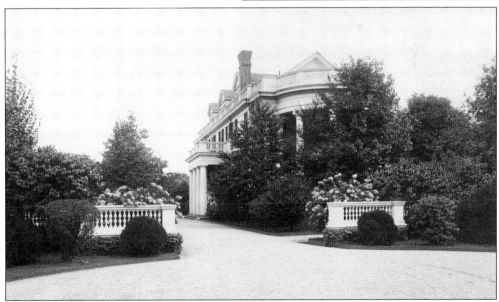

This side view of Alva Belmont's home slightly east of Hempstead Village shows the grandeur to which the millionairess was accustomed. She frequently entertained the socialites and prominent business folk who came to enjoy the Meadow Brook Club. Some, like August Belmont and Thomas H. Clowes, were heavily involved with transport such as trolleys, subways, and tunnels. (NC.)

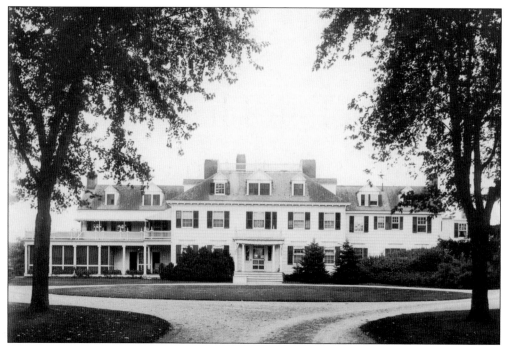

When New York City investor Henry van Rensselaer Kennedy (no relation to John F. Kennedy) married Marian Robbins, two high-society families joined forces. For their country home, the Kennedys built this gracious estate on Greenwich Street in 1894, naming it Three Oaks. Henry died in 1912. In 1947, Marian deeded the estate to the village to create Kennedy Park, which was formally dedicated in 1949. (NC.)

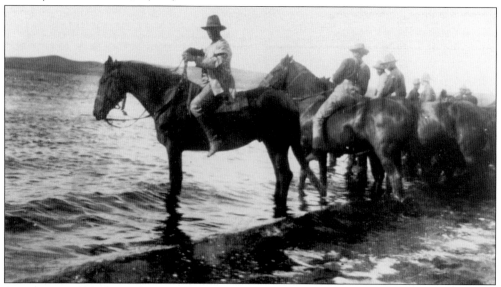

A regiment of black cavalry members, training for the Spanish-American War, takes a few moments' refreshment during exercises on a Suffolk County beach in 1898. While it is not known whether any of these men hailed from Hempstead Village, it is very possible, as Hempstead had a significant black population. Though segregated, the US military allowed soldiers of color to bravely serve their country. (NC.)

Four

THE HUB

1900–1920

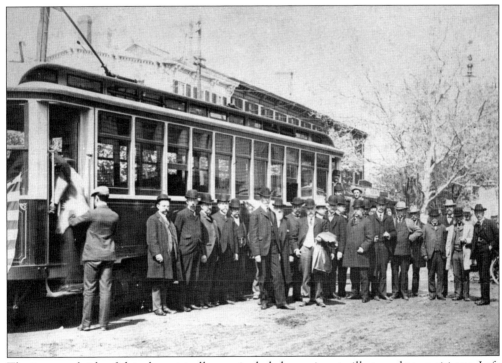

The inaugural ride of this elegant trolley car included prominent village and town citizens. Left to right of men standing and facing the camera: 4 unidentified; Judge George C. Tatem; Martin V. Wood; 4 unidentified; Judge Charles A. Gittens; Alanson Abrams; 2 unidentified; Captain William Raynor; Lewis A. Clowes; Edward Cooper; DeWitt C. Titus. In 1902, the Long Island Traction Corporation macadamized Main and Front Streets so trolley tracks could be embedded, and trolleys began running from Brooklyn and Jamaica through Hempstead to Freeport.

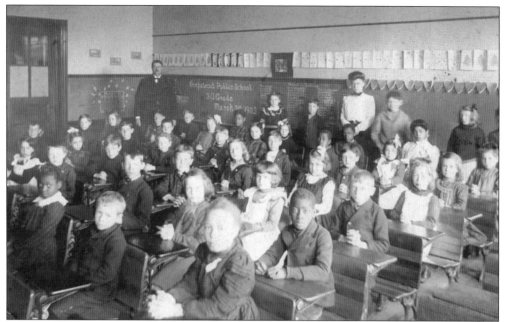

As the 20th century began, stately Hempstead Public School began to overflow. This mid-March 1903 photograph shows 42 third graders with two teachers in one classroom. Possibly two classes combined for the class picture, but the increasing need for more classroom space is obvious. Soon, primary-grade schools appeared: Prospect School in 1906, Washington Street School in 1911, and Fulton Street (now David Patterson) School and Ludlum (now Barack Obama) School in 1929.

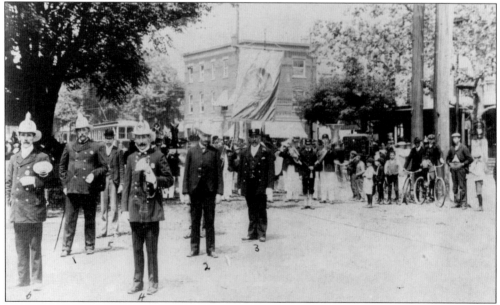

On Front Street, east of Main Street, in the early 1900s, a village fire department parade poses for a photograph. Lew Clowes, former fire chief, stands second from left with a cane. Other participating firemen included R.G. Powell, E.C. Muncke, and Stewart Cornelius. The fire departments of both Nassau County and local municipalities mounted yearly parades and tournaments, displaying progress in firefighting technologies.

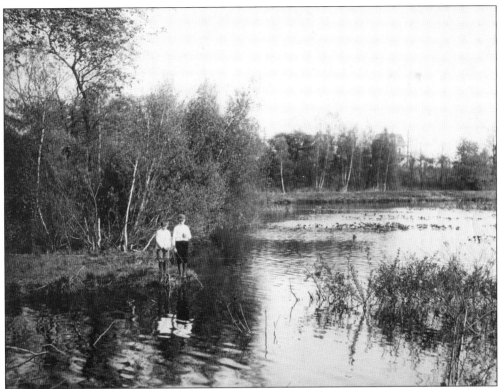

Part of Hempstead Village's appeal lay in the natural beauty surrounding it, illustrated by this scene of two boys fishing in the Hempstead Reservoir. Brooklyn's crowded population relied on this and other nearby reservoirs for water. In 1894, the waterways were extensively cleaned and renovated, becoming parkland as well as water supply. In 1926, the New York State Park System made Hempstead Reservoir part of Hempstead Lake State Park. (NC.)

William Sake Hofstra and Kate Manson (married 1895) moved into their Hempstead mansion, "the Netherlands," in 1904. Son of Dutch immigrant businessman Sake Hofstra, William presided over Nassau Lumber (Hempstead and Hicksville), became a director for Price Brothers, joined the Masons, and gave generously to local charities. Kate, active in the New York Cat Show, gave her name to the Hofstra Challenge Cup for best American cat in show. (Hofstra.)

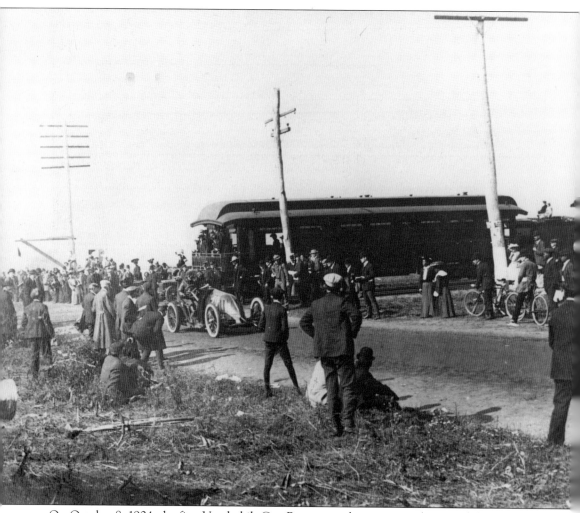

On October 8, 1904, the first Vanderbilt Cup Race carried international automobile drivers for ten laps along a 30-mile triangle of Nassau County roads, including Fulton Street (now Fulton Avenue) through Hempstead Village. Angry citizens protested race preparations that included spreading crude oil along the unpaved route and shutting down businesses for the day. American George Heath won the $2,000 prize in a 90-horsepower Panhard. This race continued yearly through 1916 but did not route through Hempstead Village again because the drivers did not like having to slow to six miles an hour within the village's borders. Its entertainment value was low, anyway, as spectators had to wait for long minutes before another car came by. This photograph was likely taken in Mineola, where wealthy viewers rented a railroad car to gain a privileged seat protected from the elements. (NC.)

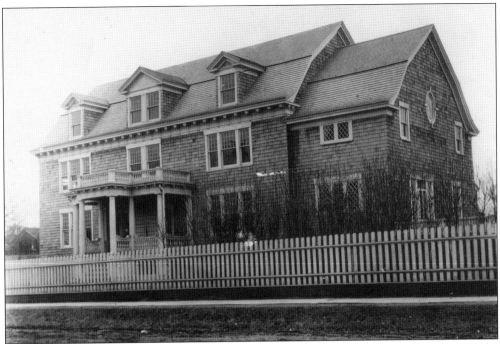

Prospect Street in 1905 received a handsome addition to the village: St. George's Parish Hall. The elegant three-story building was gifted with a gym by a former rector, Olando Harrimon, in 1911. By the 1920s and 1930s the hall was accommodating highly attended basketball matches between youth teams coming from surrounding municipalities, both boys' and girls'. It later served as an armory. Today, St. George's rents it to Redeemed Christian Chapel of Greatness. (NC.)

Fulton Park, pictured about 1905, stood in the center of Hempstead Village. It concealed the original common burial ground of Hempstead's deceased. The prosperity and population increase of the late 1800s inspired the village government to carefully record the gravestone inscriptions, bury the stones horizontally in the graves, and landscape over them with benches, paths, and greenery. Three of the gravestones still stand in the park, which is smaller now and known as Denton Green.

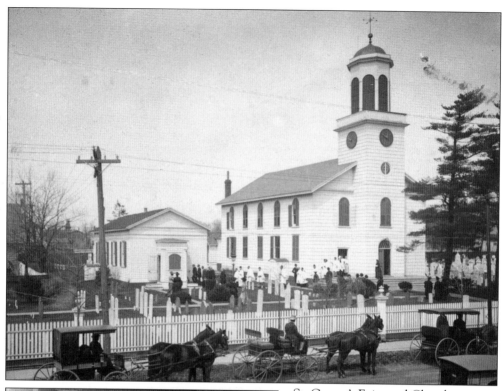

St. George's Episcopal Church on Front Street continued to unite history with modernity. In 1905, its congregation had constructed a parish house next to the 1783 rectory on Prospect Street. The 1858 clock in its tower was as old as London's Big Ben, but now power wires crossed the skyline, and parishioners could travel by trolley, automobile, or horse. In 1907, parishioners began discussing whether women should vote as members regarding church issues.

Officers of the Hempstead Bank (opened in 1887) pose at the entrance to the bank's new headquarters, completed in 1907. Pictured from left to right are Charles E. Patterson (cashier), Edward Cooper, J. Warren Allen (architect), and Martin V. Wood (president). By 1937, the bank had 26 clerks and 11,161 depositors. By 1958, it had added nine branches to its main office. This building still stands on its original site.

This 1905 photograph features descendants of several founding families. From left to right are (first row) Edith Halleck, Elizabeth Seabury, and Mr. Tibbets of Sands Point. (second row) Mr. Weeks, Judge Charles Gittens, and Mrs. Weeks. (third row) Frederick Seabury, Cora Seabury (wife of John Seabury), Alexander Halleck, Mattie Stoffel (sister of Fred Smith, who became Elizabeth Smith's husband), and Fred Stoffel.

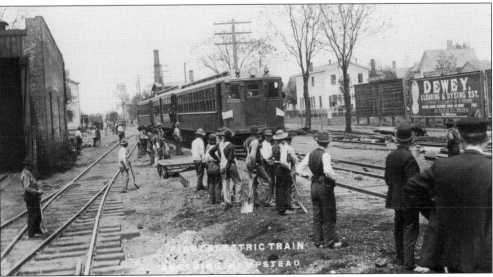

Hempstead Village citizens and Long Island Railroad workers watch the first electrified LIRR train approach the Hempstead terminal on May 26, 1908. Replacement of LIRR steam engines with cars powered by an electrically charged third rail had begun in 1905 within the New York City boroughs. Realtors supported electrification of trains to Hempstead, with its estates, parks, and services that attracted city-weary commuters seeking homes. Hempstead's population expanded rapidly thereafter.

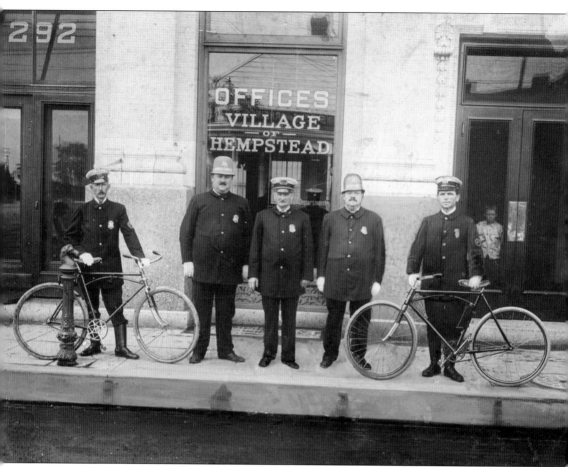

This 1909 image of Hempstead Village police at 292 Fulton Street shows police chief Robert Vandewater (center), Thomas Deyo, George Cornell, George "Cute" Gardner, and Winfield Combes. Prior to 1893, Town of Hempstead constables enforced laws. From 1893 to 1908, the new village police force had three officers: Chief Vandewater (on duty 7:00–11:00 p.m.), William L. Hooper and "Cute" Gardner (11:00 p.m.–7:00 a.m.), with Bill Gardner hired by storekeepers as needed. In 1908, village president W. Taylor Chamberlin instituted daytime patrols. The force received two more officers and headquarters in the Hempstead Bank building. Officers started wearing caps rather than helmets, and using bicycles rather than foot patrol. Gradually more officers were hired; the January 8, 1914, *Hempstead Sentinel* quoted an unnamed officer saying, "There isn't a more peaceful Village on the Island." Chief Vandewater retired in 1931.

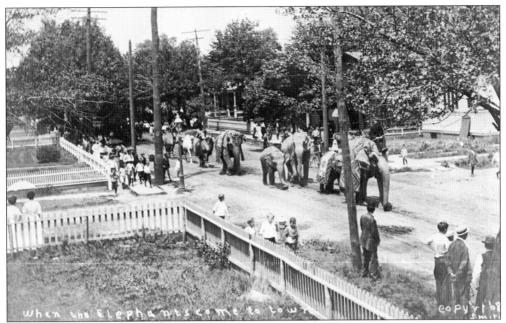

By 1910, Elizabeth Seabury had married Frederick Smith, and they had moved into Elizabeth's childhood home at 105 Main Street, across from the intersection of Main and Jackson Streets, where First Baptist Church (visible) was then located. This photograph of Spark's Circus, which visited Hempstead frequently in the first three decades of the 1900s, displays a crowd of villagers cheering elephants and camels on parade. (NC.)

Workmen on Front Street in this slightly anachronistic 1920s image exemplify the village's apt responses to technological change. Hempstead's water, gas, and electricity lines developed rapidly between 1886 and 1915, attracting moneyed homeowners to a village that offered elegant historic structures and country surroundings, yet up-to-date comforts. Hempstead's sewer system, completed during 1911 and 1912, was the first in Nassau County.

Fine Residence, Hempstead, L. I.

The fascinating home of Willis Young at Fulton and Cathedral Avenues became Sacred Heart Academy, operated by the Sisters of St. Joseph. At first Sacred Heart was in a different building at High Street and Fulton Avenue, but in 1926, diplomas were awarded for coed Sacred Heart students in the house at Cathedral and Fulton Avenues. In 1949, the Sisters of St. Joseph of Brentwood reestablished Sacred Heart as all-female.

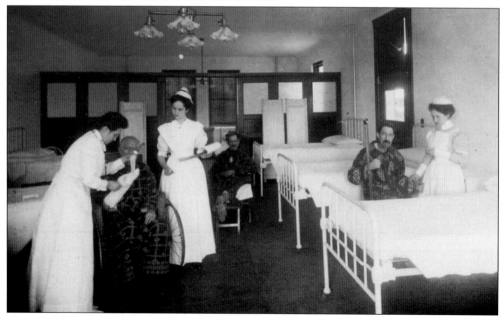

Florence McLean (left) attends patients, either at Nassau Hospital or Hempstead Hospital. The Meadow Brook Club started Nassau Hospital in a house on Fulton Avenue in 1896. It later moved to Mineola and became Winthrop Hospital. Florence McLean was a public-spirited Hempstead Village citizen who attended Christ's First Presbyterian Church.

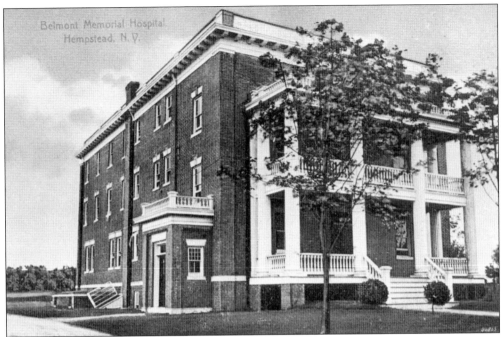

Hempstead Hospital, a project of Alva Belmont, opened in the fall of 1910 at Greenwich Street and Marvin Avenue. Florence McLean organized a "linen party" at Christ's First Presbyterian Church in June 1910, which helped to stock the hospital with bedclothes, gowns, and other necessities. Belmont envisioned a string of small hospitals throughout southern Nassau County that could fulfill local needs without the overhead so burdensome to larger hospitals. (NC.)

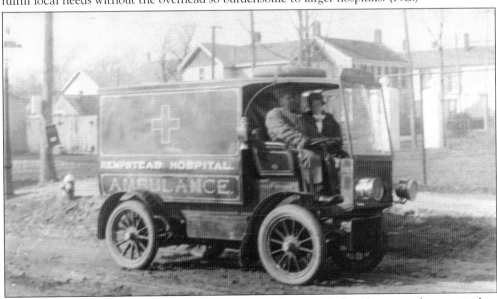

A Hempstead Hospital ambulance bounces across Hempstead's largely unpaved streets in late 1910. Alva Belmont donated and modified one of her own cars for an ambulance, and opened the administration with an all-female board of directors. Unfortunately, raising ongoing support proved difficult. The hospital closed after two years. The building was used for various purposes and eventually demolished.

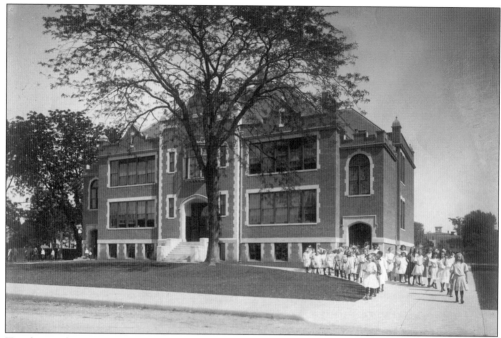

Two lines of young schoolgirls proceed from Prospect School, built in 1906, shown here around 1910. The ultra-wealthy who dotted Hempstead's outlying spaces with mansions brought fame to the village, but it was the village's network of dedicated citizens, both founding families and determined immigrants, white and black, who made Hempstead schools and services outstanding. Dignified additions to the school appeared in 1918 and 1919. (NC.)

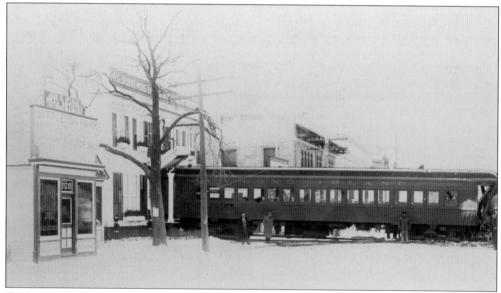

On January 6, 1912, near 11:00 p.m., a Long Island Railroad train failed to stop as it approached the old depot at Fulton Avenue. The LIRR was transitioning from wood to steel railway cars. The incoming wooden train struck this stationary steel car, ramming it through the end-of-track bumper and guard rail, all the way across Fulton Avenue and into the O.L. Schwenke Land and Investment Company building.

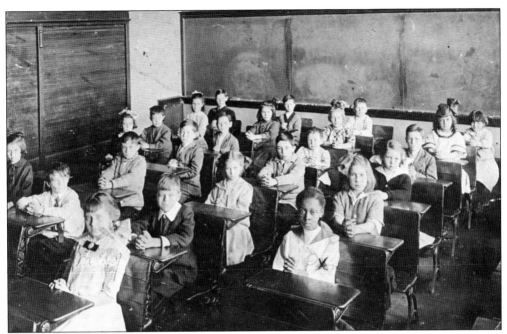

In Washington Street School in about 1912, one studious black girl named Irma Phyllis Brasier and 24 white students face the camera. Irma was born December 13, 1903, in Hempstead to Walter James Brasier, 24 years old, and Louise Frances Valentine Brasier, of 420 Fulton Street, Hempstead. Dr. Charles Ludlum attended her birth. Irma made the December 1913 fourth-grade honors list; her brother Russell, too, for second grade. (NC.)

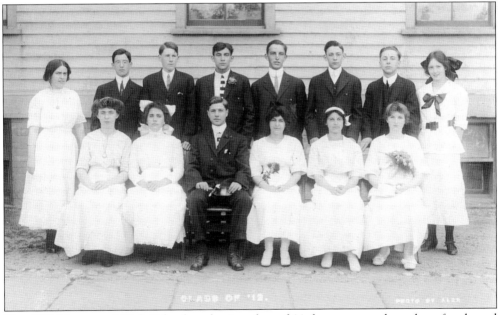

The 1912 Hempstead High School graduating class of 14 shows an equal number of male and female students. The identity of the third standing student from the right is known for certain; he was Walter Sammis, the last of the Sammis descendants to grow up and spend his adulthood in the Village of Hempstead. (NC.)

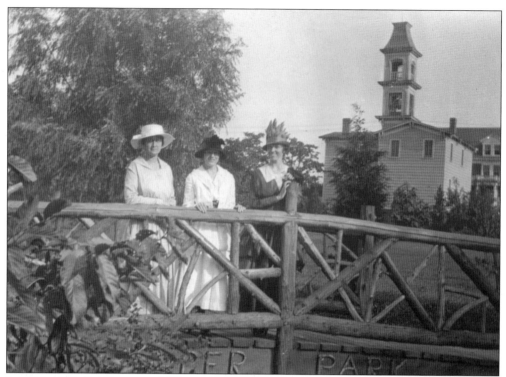

In 1911–1913, the Hempstead Women's Club that took up the project of developing Harper Park. Its two acres sported a charming brook, a footbridge, and shapely trees. Here, sisters Helen (left) and Harriet (right) Place, descendants of longtime village citizens, stand on either side of an unidentified woman, with Harper Hose and Ladder Company firehouse in the background. Today, parts of Peninsula Boulevard and the town hall occupy the Harper Park land.

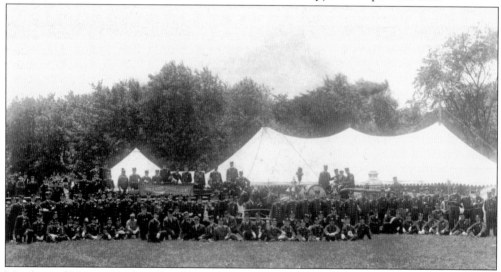

Members of Harper Hook and Ladder No. 1 gather in a field. Most likely, the Hempstead Fire Department was participating in one of the many large tournaments presented by the Nassau County Firemen's Association, which held its seventh annual parade with 4,000 firemen participating on May 22, 1909, "opposite Fulton field," according to the *New York Times*.

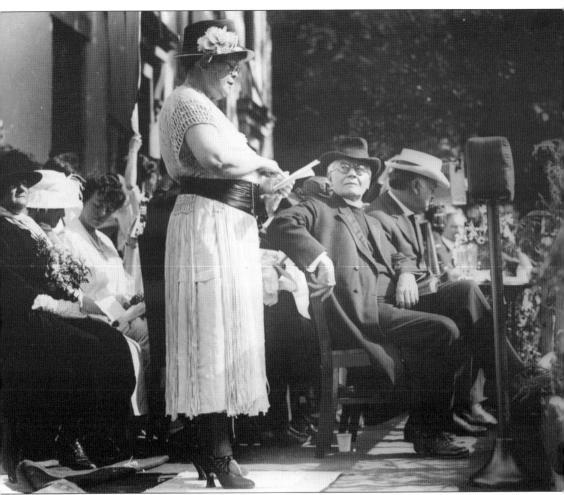

Alva Belmont, pictured here at a woman suffrage event on May 21, 1922, dedicated her time and wealth to women's rights. On May 24, 1913, she helped to lead 500 supporters of woman suffrage marching on foot, riding horses, or driving automobiles for three miles down Franklin Street, from the county court house in Mineola into the village of Hempstead. Village resident Grace Tydeman of Mrs. Belmont's Brookholt Chapter of the Woman Party led a group of young female equestrians in parade maneuvers. Boy Scouts carried banners. Aviator Charlie Hild flew his monoplane above the long column to support the cause. Hempstead Village president Floyd Weekes presented distinguished speakers before a crowd of 5,000, who had gathered to witness the arrival of the parade at Harper Park facing Prospect School. (National Woman's Party.)

Frank Martling ran this icehouse on Lowden's Pond (corner of Clinton Street and Fulton Avenue) prior to 1900; the pond then became part of August Belmont's estate. Martling also ran a coal supply for many years on Bedell Street, advertising "clean, clinkerless coal" in the 1914–1917 *Hempstead Sentinel.* From the late 1890s to about 1920, he was a school board trustee and, in the 1920s, acted as village treasurer. (NC.)

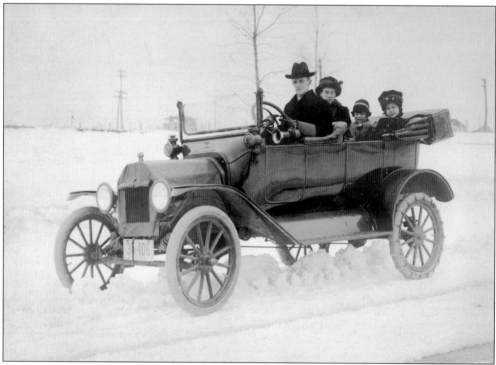

Frederick Seabury takes his sister Elizabeth Seabury Smith and her two young children, Albert J. Smith and Jeanne E. Smith, out for a winter spin in late 1915 or early 1916. Their vehicle is the recently marketed Model T Ford. The road is Meadow Street, which runs east–west along the border between Garden City and Hempstead.

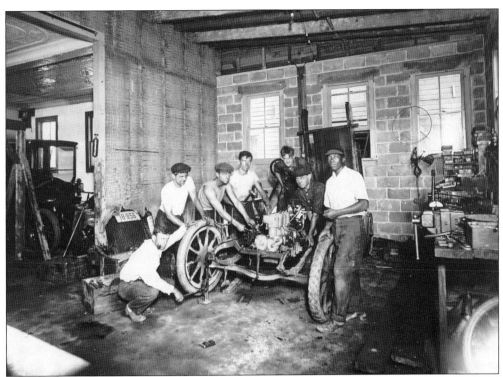

Monarch Garage, on Franklin Street north of Front Street, not only sold gasoline, but also repaired the vehicles, like Christ Auto Repair, Hempstead's first garage (1909). By the mid-1910s, firms like Standard Oil Company of New York were advertising their mixes of high-grade automobile fuel. Goodyear's had a tire shop at 277 Fulton Avenue. The automobile was well on its way to becoming the commonest form of individual and family transportation.

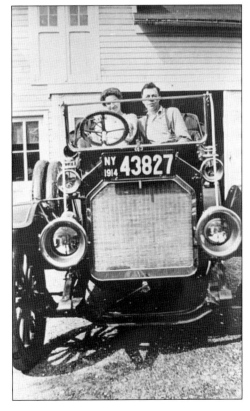

The Pflugs face the camera in an automobile in 1914. Daniel Pflug Sr. and Daniel Pflug Jr. were upstanding citizens of Hempstead Village for two generations. Daniel Sr. came to Hempstead at age 34 in 1880 and spent years with the Pflug & Ackley Bottling Company. He passed away suddenly in 1915, but Daniel Jr. continued both the business and a long association with the Hempstead Volunteer Fire Department. (NC.)

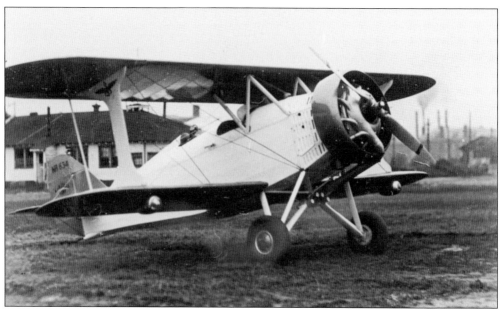

While World War I consumed Europe, US military pilots trained at Hazelhurst Fields Nos. 1 and 2, adjacent to Hempstead. When former New York City mayor John Purroy Mitchel was killed in flight training in Louisiana, Hazelhurst No. 2 became Mitchel Field. Hazelhurst No. 1 became Roosevelt Field in 1919 to honor Theodore Roosevelt's son Quentin, lost in air combat. Pictured is the 1934 aeronautics Laird biplane owned by Maj. Alexander De Seversky. (NC.)

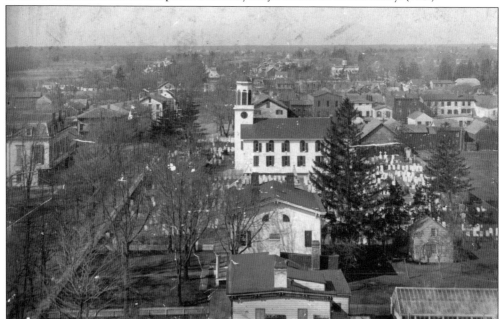

The late-19th-century occupant of the little house on the rear of the Harper farm was an African American, Jonas Mayhew, the Harper farm overseer. Around 1920, Thomas O'Shaughnessy moved the little house to sit behind Isaac Snedeker's 1810 house on Washington over objections from local bigots. This photograph shows the Snedeker house (now Parking Lot 1), center, with the little house at right, St. George's beyond, and Liberty Hall at left.

Five

THE EXPANDING HUB

1920–1940

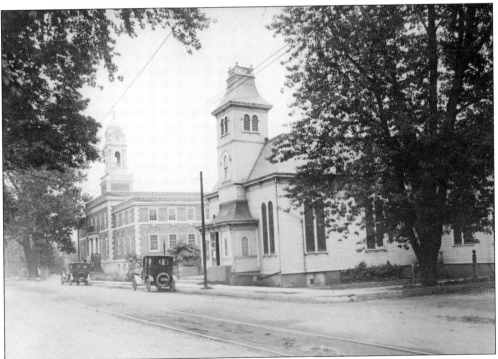

The 1870 Town of Hempstead Town Hall and its 1918 replacement stood side-by-side on Front Street until the older building was demolished during the summer of 1920. The 1918 town hall still commands Front Street. Changes during the mid-1930s through the mid-1960s eliminated Harper Park and the "horse brook" (Rockaway Stream) that flowed through it, which also eliminated the brook's periodic flooding. (NC.)

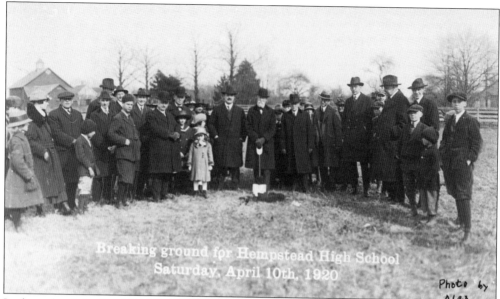

In the wake of the April 5, 1919, fire that demolished the 1889 Hempstead High School building, its grand replacement arose on Greenwich Street above Totten Street—the site of today's middle school. Participants at the ground-breaking ceremony on April 10, 1920, included board of education president Dr. Charles H. Ludlum (holding spade). Directly to his left are school board member Arthur Philips and school superintendent J.T.P. Calkins. (NC.)

Nassau Garage opened at 78–80 Main Street in mid-September 1920. Hempstead proprietors Louis F. Hutcheson and Ralph Foreman arranged the first floor with an accessory shop, an automobile showroom, large repair bays in the rear, and storage for 40 cars. The second floor sported four office areas for rent. Nassau Garage was a chain; this still-standing building was called "splendidly equipped" by the September 16, 1920, *Hempstead Sentinel*.

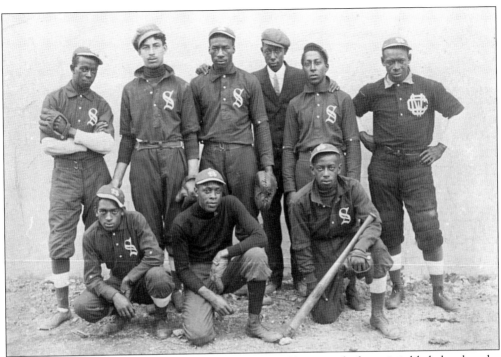

The baseball team pictured here in 1920 may be from Hempstead; if not, it is likely local to the Hempstead environs. Baseball teams abounded during the first decades of the 20th century. Many black teams were professionally managed. The names of top-notch black teams and their best players appeared frequently in the news, and tournaments between black and white teams were quite popular. (NC.)

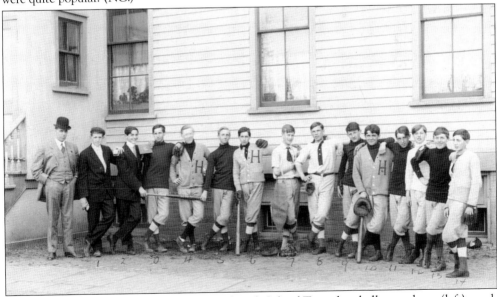

The mid-1920s photograph of the Hempstead High School Tigers baseball team shows (left) coach Joseph H. Fay, who coached 1920 to 1947. The 10th boy from the left is Floyd Stafford, who was the son of a prominent tire shop owner. High school sports had faded during the pressures of war but was revived and rapidly flourished under Joe Fay.

By 1928, the elder Floyd Stafford—golfer, billiard player, and Hempstead Lions' Club member—had established the Hempstead Tire Repair Shop at 265 Fulton Avenue. In 1929, a committee including Stafford and Carman R. Lush advocated for annexing East Hempstead into Hempstead Village (which later occurred). A 1935 *Hempstead Sentinel* article about apportioning fire and police expenses noted that the problem was discussed "back of Floyd Stafford's"—seen in this 1932 photograph.

On May 28, 1921, the Hempstead Country Club opened, with nine holes ready for play by October 1 and three tennis courts. A businessman named B.W. Jones donated money for a tennis tournament cup. The club property had been a rough farmhouse on 143 acres owned by the Parsons family, who had come to Hempstead in 1884. Club members' wives refurbished it for modern use. The club still operates.

Calderone's picturesque Hempstead Theatre graces the south side of Fulton Avenue between Main Street and Washington Street. Salvatore Calderone, a successful merchant who had run Manhattan theaters with his brother prior to World War I, envisioned a 2,000-seat venue that would excel anything in Nassau County. William E. Clowes' venerable house was bought, its tenants moved out, and the theater opened in 1922 with 1,800 seats. (NC.)

In mid-August 1923, the Hempstead Professional Building for physicians and dentists opened at 131 Fulton Avenue. Until then, physicians' offices and equipment were in their homes. Here, they had x-ray machines, a laboratory, an operating room, and a telephone system specially designed by New York Telephone. The seven-story brick edifice still stands.

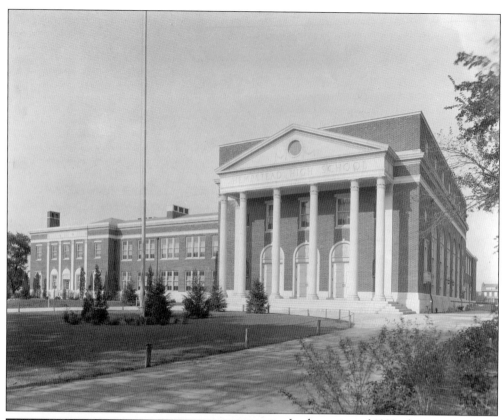

In the spring of 1922, the new Hempstead High School opened for classes. Its grand façade and state-of-the-art facilities fit this moment in the village's life: the end of World War I was 18 months past; technologies of transport, architecture, and communications were booming; and Hempstead businesses started raising more and more grand edifices. In 1911, the enrollees in high school numbered 82; by the fall of 1922, there were 662. (NC.)

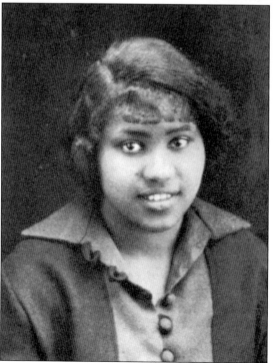

Vivian Schuyler graduated in 1924 from Hempstead High School, as represented by this 1924 yearbook photograph. Schuyler, who helped edit the yearbook and participated in art club, was denied a valedictorian speech because she was African American. She went on to become Vivian Schuyler Key, a renowned artist of the Harlem Renaissance and beyond. (Hofstra.)

Irma Brasier's yearbook picture and image with graduation gown commemorate her 1924 graduation from Hempstead High. While a complete picture of her life from graduation until her 1986 death in Hempstead at age 82 is not available, bright glimpses exist in past issues of local papers. The *Nassau Daily Review-Star* for April 30, 1937, notes that Brasier was recording secretary of the South Franklin Street Republican Club of Hempstead. The same paper, March 9, 1946, states that Brasier (among others) assisted Mrs. Albert Holmes, soloist at the World Day of Prayer observation at the Hempstead AME Zion Church. The *Long Island News and the Owl,* May 9, 1947, notes that Brasier was the "talented colored soprano" soloist at a meeting of the Nassau County Federation of Republican Women, earning applause worthy of famed African American soprano Marion Anderson. (Above, Hofstra; below, NC.)

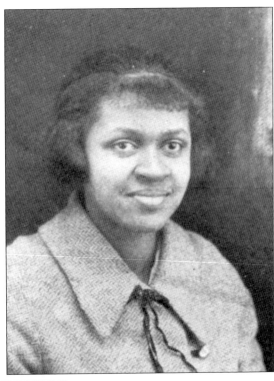

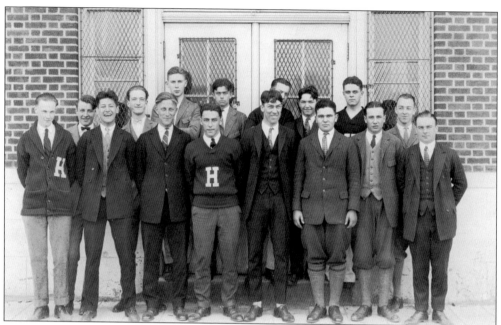

Coach Joseph H. Fay stands at the right of his Tigers football team in the mid-1920s. Hired in 1920, Fay is credited with reviving Hempstead High athletics after World War I. Under Fay, the football team was undefeated in 1924, 1928, 1937, 1939, 1941, 1944, and 1947. One of his students, Leo Sexton, broke an arm and missed competing in the 1928 Olympics decathlon, but he won gold for shotput in 1932. (NC.)

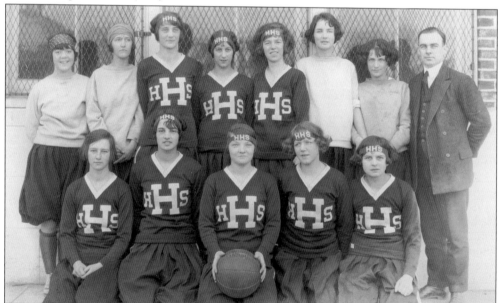

Coach Fay also inspired girls to greatness. His 1925 Tigers girls' basketball team won the Westfield Cup, a national competition. Mary Washburn, 1924 captain of girls' track and basketball team member, won a silver medal for relay in the 1928 Olympics, the first one in which women competed. Fay also developed cheerleading in a decade when women were just beginning to cheerlead, and acrobatics were added to halftime routines. (NC.)

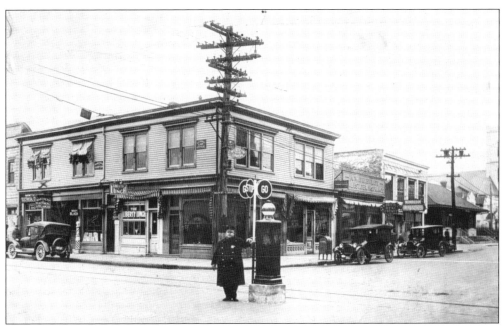

George "Cutie" (or "Cute") Gardner stands at Fulton and Main Streets directing traffic in about 1925. Portly and congenial, he was the darling of village residents as well as soldiers from Camp Mills and Mitchel Field who came to shop. When he died in 1926 at age 54, after 33 years with the Hempstead Police Department, the *Hempstead Sentinel* called him "probably the most-photographed and most widely known policeman in the United States."

Our Lady of Loretto Roman Catholic Church and rectory graces 115 Greenwich Street in 1925. Hempstead had few Catholics prior to 1850, after which Irish and German immigrants began to arrive. The first Mass was celebrated at the home of Barney Powers in 1840 by Rev. John O'Donnell. Reverend Eugene McSherry became pastor in 1871. A Catholic school opened under Sisters of Charity BVM in 1927. The present buildings were dedicated in 1954.

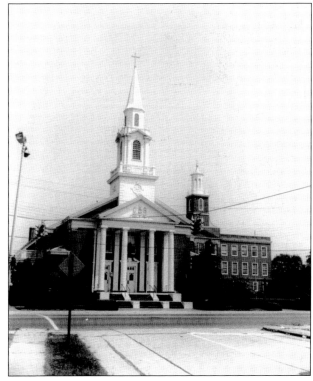

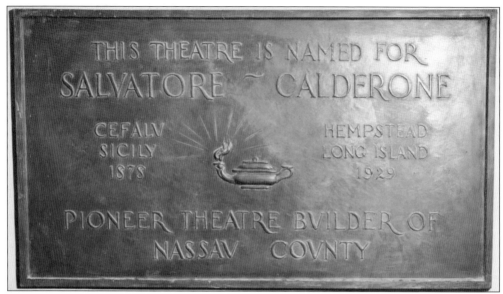

The *Nassau Daily Review* reported the April 3, 1926, opening of Calderone's Rivoli Theatre, a 2,200-seat theater at Main and Columbia. It boasted parking space, a location "outside" the business district, modern heating and ventilation, toilets, retiring rooms, and smoking rooms. Calderone built six successful theaters in Nassau County in four years—commemorated by this plaque, which appeared on a 1949 theater built by Dr. Frank Calderone, Salvatore's son. (Hofstra.)

By 1927, the changes incurred by post–World War I business expansion and the vastly increased availability of cars became more visible. Here, yet another Louis Cohen–built brick structure houses Jack and Jerry Tire Stores on one corner of Main Street and Jackson Street, a block and a half north of the grand 1892 "business block" on Main between Fulton Avenue and Front Street.

A noble church bell, elegantly inscribed in Polish, dated 1927, commemorates the 1915 founding of St. Ladislaus Church on Front Street and Richardson Place. Rev. Wladyslaw Manka (William Manka) was the parish founder. Polish immigrants to Hempstead between 1901 and 1915 held services in the building that now acts as the rectory to the present church building, which was dedicated by Bishop Thomas E. Molloy on January 8, 1928. (NC.)

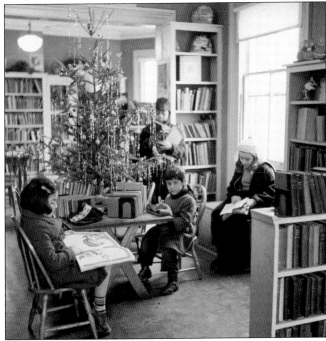

On Friday, July 1, 1927, the cottage library could no longer hold its contents. It was moved to a mansion known as the Baker House, at 189 Fulton Avenue, on the northwest corner of Fulton and Terrace Avenues. Its interior is shown here. It answered the needs of the community for literacy and children's activities until the current building was built in 1951.

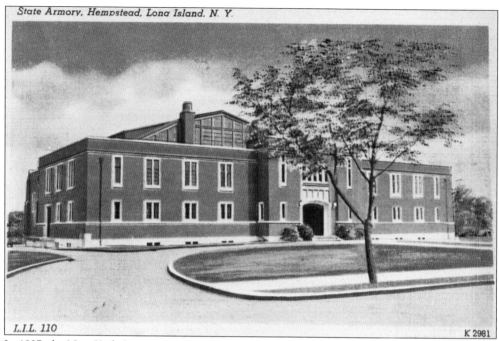

State Armory, Hempstead, Long Island, N. Y.

L.I.L. 110 K 2981

In 1927, the New York State Government approved a bill to construct a National Guard armory on Washington Street. Two companies of the state's National Guardsmen in Hempstead had been housed in the parish house of St. George's since 1914. The new building, of then-modern materials of brick, stone, and steel, was the first armory authorized by the state to be built outside the Greater New York area. (NC.)

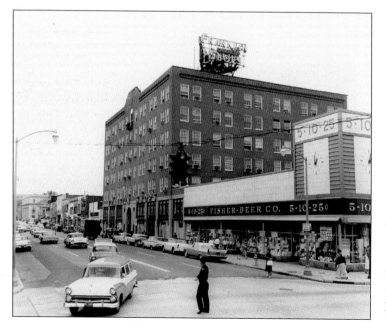

On October 29, 1927, the Franklin Shops (shown early 1960) opened at Fulton and Franklin Streets with weeklong promotions. Manager Albert Franklin stated to the *Hempstead Sentinel* that he "located in Hempstead because it is the logical center of a rich trading area." The building had three retail floors, three office floors, and parking for 200 cars. It went out of business on April 13, 1960, and became office space.

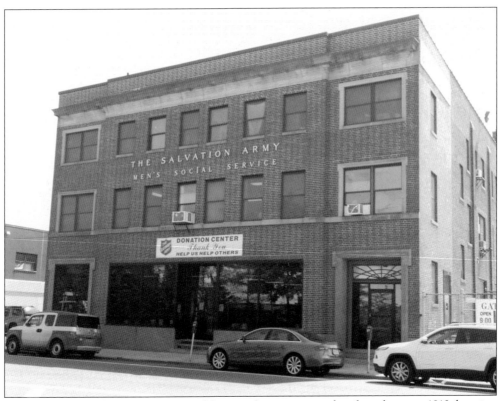

The Hempstead Salvation Army Social Service Center accepted its first clients in 1912, housing them in a large old residence. Horse-drawn wagons ferried supplies and people along the well-kept but mostly unpaved village streets. Twenty-nine years later, the current facility at 194 Front Street opened its doors. Its programs provide rehabilitative counseling, employment information, some on-premise jobs, and an extensive thrift shop. (Charles Bethany.)

This idyllic photograph of Jackson Main School soon after it was erected in 1929 conveys Hempstead's former spaciousness. A letter to the Hempstead Village Board of Trustees, May 24, 1928, states the "premises bounded on the north by Columbia Street, east by Westbury Road, south by Jackson Street and west by Bennett Avenue" were sold by Roana Realty Corporation to School District No. 1 of the Town of Hempstead.

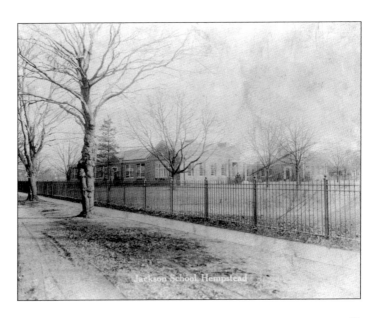

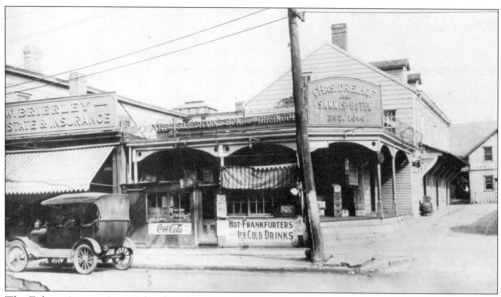

The Fulton Avenue Long Island Railroad Station had been located in the yard of Sammis Tavern in 1872. In 1892, the tavern was moved 100 feet eastward and rotated 90 degrees so that its western end faced south, as pictured here. Henry Sammis ran the tavern until 1918. His son Walter was the eighth and last Sammis generation born under the inn's roof. In 1919, most of the inn was removed; in 1929, it was demolished.

In 1930, the New York Telephone building was erected on the northeast corner of Fulton Avenue and Terrace Avenue. The number of telephones in Nassau and Suffolk Counties combined had surpassed 100,000 by mid-1929. The business office that had been at 352 Fulton Avenue was moved to the new building's ground floor, with switchboard and central office equipment on the second and third floors, and divisional offices above that. (NC.)

Bohack's Quality Stores was a chain established in 1887 by German immigrant Henry C. Bohack, who left his family several million dollars in 1931. This building at the southeast corner of Washington Street and Fulton Avenue supplied groceries starting in the late 1920s or early 1930s. Bohack's was renowned; a mention of the Bohack's at Greenwich and Henry Streets, where a large CVS now stands, evokes smiles from older Hempstead residents.

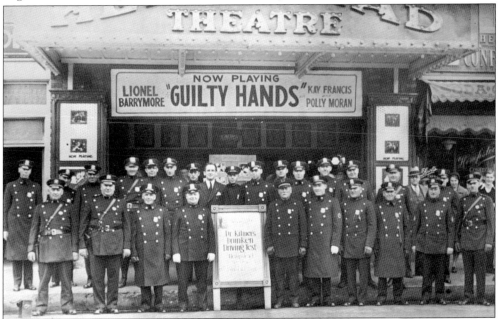

Hempstead police stand outside Hempstead Theatre on Fulton Avenue, which advertises the 1931 Lionel Barrymore film *Guilty Hands*. Twenty-three years after Henry Ford's Model T made cars affordable for households, drunk driving had become an issue for which the police department developed an outreach program. Decades later, in 1985, the theater was occupied by the Division of Motor Vehicles, which retained its magnificent ceiling. The building now houses Winners Christian Ministry.

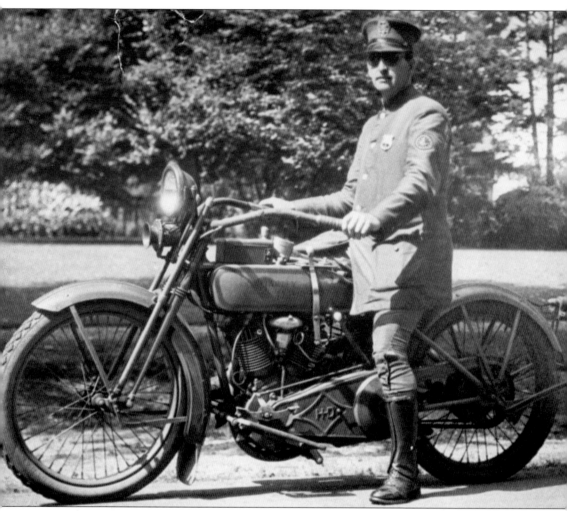

Motorcycle officer John L. Feeley started as a rookie in 1918, when older officers still rode bicycles. Officer Feeley made sergeant in 1924, lieutenant in 1928, and chief in 1944; he was still chief when interviewed by the Hempstead Beacon in 1956, and his oldest son, another John L. Feeley, was a sergeant in the Nassau County Police Department. Feeley was also a Hempstead volunteer fireman for 49 years. The date of this photograph is unknown, but a *Hempstead Sentinel* article of August 23, 1923, describes "Motorcycle officer John L. Feeley" rescuing seven people from an overturned Buick on South Franklin Street by helping them climb out of the car with a stepladder.

In 1930, the Lutheran Church of the Epiphany sold its site on Fulton Avenue and High Street to the US Post Office for $140,000. It bought its present site on Fulton Avenue between Hilton and Meade Streets. Its artistic, enduring church building, parish house, and parsonage were dedicated on June 5, 1932. By 1937, it had 400 members.

In 1932, the Hempstead Post Office moved from Main Street into its present home, 200 Fulton Avenue, on the southwest corner of Fulton Avenue at High Street. In 1937, Works Progress Administration artist Pappino Mangravite painted murals at each end of the main chamber. One depicts the settlement of Hempstead by the British. The other celebrates the 1919 flight from Scotland to Roosevelt Field of the British dirigible R-34. (NC.)

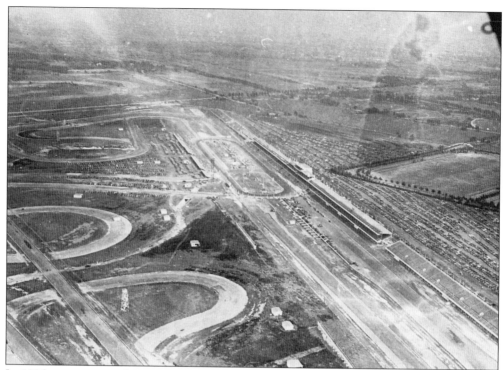

In 1935, construction began on Roosevelt Raceway in Westbury on incorporated Town of Hempstead land not to race horses, but cars. George Vanderbilt had decided to revive the W.K. Vanderbilt Cup, which had not run since 1916. On Monday, October 12, 1936, in the opening 300-mile race with 1,200 turns around the rough looping track, Italian Tazio Nuvolari took the grand prize among the $60,000 of prize money given out. (NC.)

Archibald Holly Patterson, born in Uniondale on May 31, 1898, later moved to Hempstead and was the first presiding supervisor of Nassau County to hail from the village. His father was Archibald G. Patterson, the Hempstead town highway superintendent. A. Holly became corporation counsel for Hempstead Village. Five hundred people came to a testimonial dinner for him and gave him ovations when he was elected presiding supervisor in the fall of 1933.

Six

THE ONGOING HUB

1940–1957

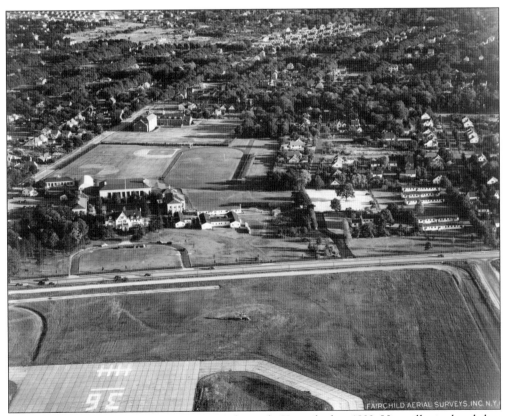

William Hofstra died a millionaire in 1932; his wife, Kate, died in 1933. Her will stipulated that their mansion and 15-acre estate (pictured at middle left) be used for public good. Several prominent friends converted the estate to a two-year feeder school to New York University, renaming the mansion Hofstra Hall, where classes first occurred on September 23, 1935. Hofstra College received its charter February 16, 1940, as an independent four-year baccalaureate institution. (Hofstra.)

Sports was not Hempstead High School's only claim to fame. Scholastics increased, as evidenced by these members of the 1940 Pentagon Club, an honors club for 11th- and 12th-grade boys. During the 1950s, Hempstead High's orchestra and choir, under Imogen Boyle, gave yearly programs at Hempstead Theatre. In 1955, renowned American composer Morton Gould conducted the young musicians through one of his own compositions and Aaron Copland's *Billy the Kid*.

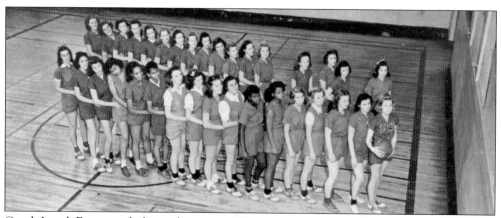

Coach Joseph Fay not only fostered too many Tigers sports to mention; he also joined the progress away from racism by opening his teams to nonwhite students, as this 1940 photograph of the Tigers girls' basketball team shows. In 1933, Zach Embry become the school's first black football player. In 1957, Ollie Mills became Hempstead High School's first black coach. Athletes of color have figured prominently in Hempstead schools ever since.

In 1941, the United Services Organization Inc. (USO) combined six civilian organizations under one banner to provide support and entertainment to US military members. On Monday, November 10, 1941, ground was broken at 99 Nichols Court for the Hempstead USO building, with then-mayor Herbert Mirschel and officials of Mitchel Field Airbase present. It was the first federal soldiers' club on Long Island. On May 8, 1944, First Lady Eleanor Roosevelt encouraged the servicemen with a personal visit.

On May 30, 1942, the Ladies Auxiliary of the Hempstead Volunteer Fire Department joined the annual Memorial Day parade. These women are marching across Front Street, into which Main Street dead-ended at the time. Cranes Furniture, a huge store that opened in Hempstead early in 1941, stands beside Lush Pharmacy, by then 56 years in operation.

In October 1943, Hempstead Village celebrated its tercentenary. Four thousand students participated in a pageant, portraying early village history in a series of skits. A retrospective of colonial days included live sheep on Denton Green. Here, gardening in the old-fashioned way are, from left to right, Walter Sammis (last living Sammis); his father, Henry Sammis (age 85, last Sammis Tavern proprietor); Henry Hicks (holding adze); Mignon I. Sammis; and Emma Sammis.

Irma Brasier's parents, Walter James Brasier and Louisa Valentine Brasier, are pictured in 1943. Walter worked as a dental apprentice, next as a chauffeur, and finally as a dental technician. In addition to Irma, Walter and Louisa raised two sons, Russell and Valentine (whose name appears as "Reginald" in the birth records of 1906, with his last name incorrectly written "Brazier"). Dr. Charles Ludlum attended all the Brasier births.

Early in 1947, the H.V.R. Kennedy mansion and its 22 acres of property were purchased by Hempstead Village. The land was immediately named Kennedy Memorial Park, and the mansion, Kennedy House. Although activities for 1,700–1,800 youth were conducted during the summer of 1947 and 1948, the park was not formally dedicated until 1949, an occasion at which Brig. Gen. Reginald Vandewater, son of *Hempstead Sentinel* editor Lott Vandewater Jr., spoke. The Hempstead Child Care Center established a space there, as did the Long Island Chapter of the Association for the Help of Retarded Children. By this time, park space elsewhere in Hempstead had been eaten up by developers and nearly all of its streams and ponds buried. Citizens acknowledged the importance of creating what Kennedy Memorial Park has become: a much-needed recreational and meeting facility for families and village events.

Children view a Rag Doll Theatre production at Hempstead Library, likely around 1948, before incorporation as Hempstead Public Library at the present site on Nichols Court. Throughout its history, Hempstead Public Library has faithfully provided activities for its diverse young population: holiday gatherings, monthly presentations of theater, music, arts and crafts, bilingual events, and weekly story time.

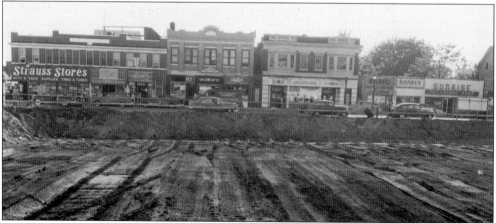

By the late 1940s, increasing population sparked transportation changes. Trolleys would disappear completely by the early 1950s. Gas-powered buses running heavy schedules took over. A one-block-square bus terminal arose above Nichols Court on Main Street. Visible on the west side of Main Street across the construction site are A&S Stores and Chun King Restaurant, both later replaced by the Nassau County Courthouse in 1979. The repurposed terminal building still occupies the site.

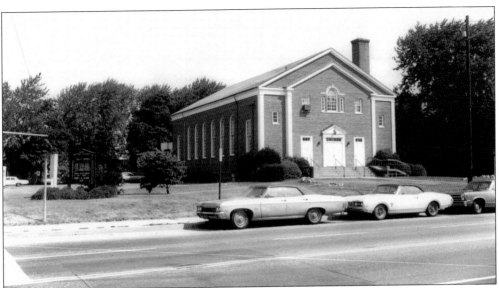

By 1948, the First Baptist Church congregation had outgrown its building at the intersection of Main and Jackson Streets. Frank Martling's property at the corner of Jackson and Washington Streets was purchased. On May 30, 1950, the congregation moved their church's contents into a 40-by-80-foot tent in Martling's yard and held the first service of the new location on June 4, 1950. Before long, the current church (pictured, early 1960s) stood complete.

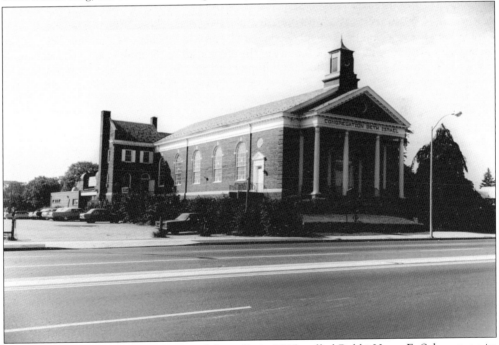

Congregation Beth Israel, incorporated formally in 1915, called Rabbi Harry E. Schwartz to its leadership in 1933. By 1947, ground was broken for a new, larger synagogue at 94 Fulton Avenue. In 1948, adjoining property on Fulton Avenue became a temporary school building. March 26, 1950, marked the dedication of the synagogue at 94 Fulton Avenue, architecturally the most beautiful synagogue on Long Island. Four floors of classrooms were dedicated in 1957.

In 1948, the Hempstead Village government moved, from the space it shared in the Hempstead Bank Building at 292 Fulton Avenue, into the USO building at 99 Nichols Court. The USO disbanded into its separate organizations for a time after World War II. Its unused quarters were readily adapted to become the village headquarters. The Hempstead Police Department, too, received new quarters at the rear of the USO building.

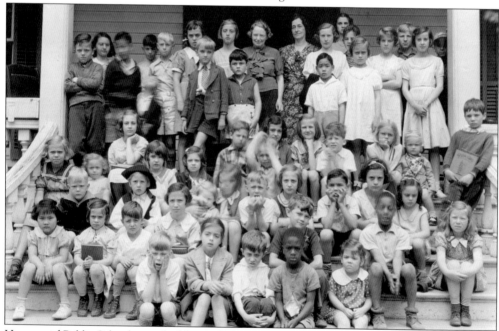

Hempstead Public Schools were highly rated, if not problem-free. These children sitting on the steps of a Hempstead school about 1950 capture the increasing diversity in Hempstead. Neighborhoods were often racially separate, leaving some schools mostly white, some mostly black, others a near-even mix. Efforts to even out the population were rarely effective. Thurgood Marshall sued in New York State Supreme Court because Prospect School by 1949 was 93 percent black.

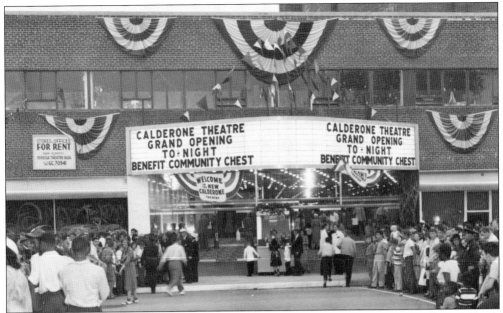

Salvatore Calderone died on February 10, 1929. Twenty years later, on June 21, 1949, his son Frank opened the 2,500-seat Calderone Concert Hall at 145 North Franklin Street. Pictured is the opening-day crowd; the full opening event included parades and bands. Although intended for opera and huge musicals, during the 1970s and 1980s the Calderone hosted popular musicians like Jerry Garcia, Aerosmith, the Allman Brothers, Hall & Oates, and Lou Rawls, to name a few.

On opening night of Calderone Concert Hall, the first row included community luminaries, from left to right, theater financier Nick J. Matsoukas, Hempstead Village mayor Ernest Ashdown, J. Russell Sprague, Sheriff Theodore Vollmer, Kenneth Harder (head of Hempstead Community Chest, a charitable organization), Dr. Mary S. Calderone and her husband, renowned Dr. Frank Calderone. The opening night proceeds went to the Hempstead Community Chest. (Hofstra.)

An immense Abraham & Straus (A&S) retail store arose toward Fulton Avenue's western end in 1952. The original A&S stores were founded by Abraham Abraham and Joseph Wechsler in 1865. In 1893, Nathan Straus, Isidore Straus, and Simon F. Rothschild bought out Wechsler and the store became Abraham & Straus. Isidore Straus perished with his wife on the RMS *Titanic* in 1912, but his partners carried the business forward.

In 1950, Hempstead Village's official population was 29,135. Responding to the increased need for book inventory and activities, Hempstead Public Library was incorporated and the cornerstone of the present building was laid. It opened in 1951. As the baby boom brought more and more children into schools and public buildings, a branch of the library was added in Kennedy House at Kennedy Memorial Park.

Alfred Windt (left), son of a Rochester mathematics teacher, served several decades in Hempstead Public Schools. In 1947, he was faculty advisor to the Student Council of Hempstead High. In 1951, he was assistant principal and director of extracurricular activities. In this September 1956 photograph, Windt and school superintendent Dr. Amos Kincaid discuss an open file. The 1969 yearbook was dedicated to Windt.

Rev. William C. Evans (left), pastor of South Hempstead Baptist Church, speaks with Chief John Feeley in 1956. Reverend Evans led the fund drive for the Parkview Youth Center at 71 Maple Avenue, which would have stood on Maple between present-day Laurel Avenue and Evans Avenue. Endorsed by Mayor William Gulde, the center was to have space for church social functions as well as youth activities and a day nursery.

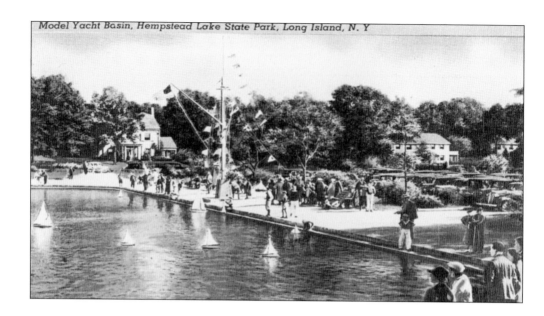

Model Yacht Basin, Hempstead Lake State Park, Long Island, N. Y

By 1954, Hempstead Village was already feeling the downside of changes made decades before. In 1926, New York State established a state park system. It converted Hempstead Reservoir into Hempstead Lake State Park, which included the model yacht basin depicted above in about 1950. The beautiful bridle paths in the photograph below were at first trodden by horses from three stables; but business increased, until six stables and a huge arena of surrounding land known as Hempstead Gardens, housed not only a riding academy but also a series of prize fights and then a farmers' market. The stables attracted a rougher crowd; drunkenness and petty crime increased.

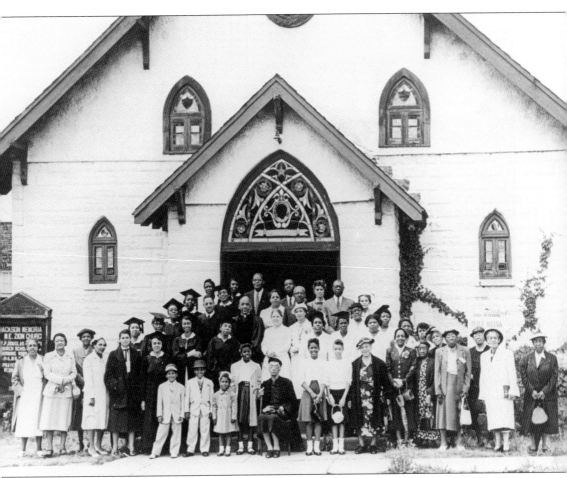

Jackson Memorial AME Zion Church is pictured here with its congregation in 1954. By that date, increasing traffic called for widened roads. Mill Road along the eastern edge of Hempstead State Park, Prospect Street, Grove Street, and South Franklin Street, all were changed, and four stables eliminated. The Ackley Beverage Corporation at Prospect and Greenwich Streets was removed, along with seven dwellings, Union Baptist Church, Jackson AME Zion Church, and the 1873 firehouse, whose iron bars and basement had also housed the village jail. Altogether, Nassau County bought 151 parcels of land. The much-wider Peninsula Boulevard extension ran south from Fulton Avenue along what was once Cross Street, curved west along the former Prospect Street, and then south through Rockville Center toward Long Island's southern shore. Union Baptist Church and Jackson Memorial Church rebuilt elsewhere in the village.

These grand old homes on Terrace Avenue, which 120 years before had been named Benjamin F. Thompson Place after the renowned 19th-century historian, gradually emptied as early Hempstead family lines died out or business owners retired and moved on. Shown here in 1958, these houses stood until the early 1970s, when the west side of Terrace Avenue was replaced with luxury apartments.

Roosevelt Field closed as a military airfield in 1951. In 1955, an open-air mall opened there with plentiful parking, popular chain stores, and an ice rink. To regain business lost to the mall, for one week in October 1959, Mayor William O. Gulde and volunteers created a temporary plaza with flowers and benches on Main Street. So much business flowed from this mini-mall that it was replicated for a week in mid-December.

Seven

DIFFICULTIES AND OVERCOMING

1957–1980

A. Holly Patterson, shown here with New York State governor-elect Nelson Rockefeller, remained a popular and admired public servant until his death in 1980. A lifelong Republican, he acted as Nassau County executive from 1953 to 1962. Patterson's long record of civil service was immortalized in A. Holly Patterson Library on the campus of Nassau Community College, A. Holly Patterson Extended Care Facility in Uniondale, and Holly Road in Hempstead.

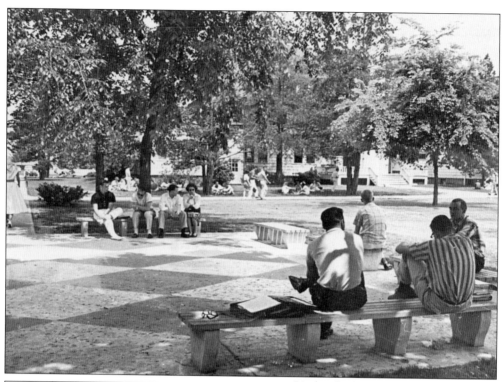

Under the leadership of Hofstra College president John Cranford Adams, the college expanded to become Hofstra University, offering postgraduate degrees. When the military airfields on Hempstead Plain began to close, Hofstra increased the acreage surrounding the original Hofstra Mansion on the south side of Fulton Avenue by purchasing land on the northern side. In this early 1960s photograph, taken on the scenic original grounds, students rest and chat on a summery day. (NC.)

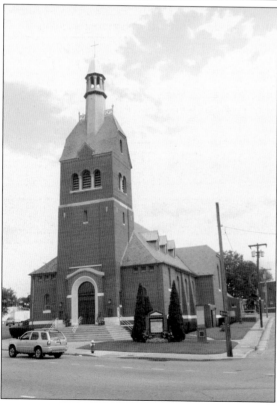

St. Ladislaus continued growing. Through the decades, it found ways to school its parish children, and by August 1963, a new rectory on the site of the old one plus a group of school buildings had been completed. The Felician Sisters from St. Hedwig's in Floral Park formed the teaching staff, with two lay teachers. As Hempstead's demographics shifted, some buildings were repurposed to serve Hempstead Public Schools. (RB.)

The Dorothy K. Robin Child Care Center operated for several decades of the mid-20th century at 370 South Franklin Street in the southeastern end of Hempstead Village. According to a 1969 issue of the *Long Island Clubwoman*, it was named for its founder, a citizen who foresaw a growing number of two-income families. Large playgrounds surrounded the three-story, fireproof building.

A football parade accompanies the dedication of Kennedy Memorial Park's recreation building, which replaced Marion Kennedy's mansion in 1961. The recreation building has a vast gym frequently occupied by youth sports teams, an auditorium with stage and kitchen facilities, a large community room with pool tables and space for athletic activities such as martial arts, and workout equipment rooms on the lower level.

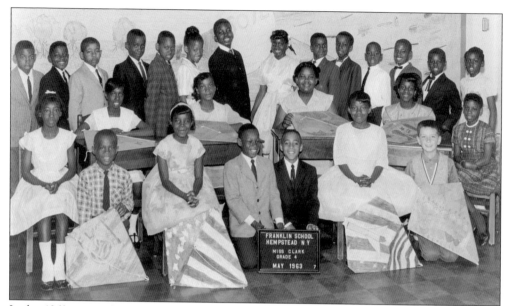

In this 1963 image of fourth graders at Franklin School on South Franklin Street, Doris Henderson, who contributed the four classroom photographs on these pages, is seated second from the right in the first row. The 1960s saw population migration from south to north, as southern farming income slowed and northern manufacturing increased. Doris earned a bachelor's degree and had a career in aerospace firms, starting with Fairchild Republic in Farmingdale.

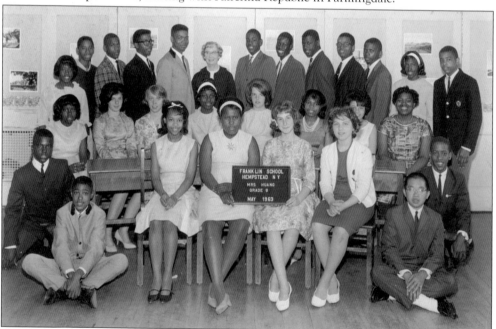

The young lady seated in the first row on the left is Dr. Cheryl Halliburton, associate professor of dance at C.W. Post campus of Long Island University (LIU). She holds several degrees, including a doctorate in interdisciplinary studies. She has taught dance, music, and history in West Chester, Pennsylvania, Nassau Community College in Garden City, and Manhattan's Lincoln Center, in addition to her 21 years of professorship at LIU Post.

The 1962 Franklin School fourth-grade glass included Deborah Priestley DeLong, farthest right in the first row of girls. She was among the students whose high school years were interrupted by the July 1970 fire that demolished the 1922 high school building. She graduated despite difficult classroom arrangements while the current high school building was under construction and is today Hempstead High School's assistant superintendent for pupil personnel services.

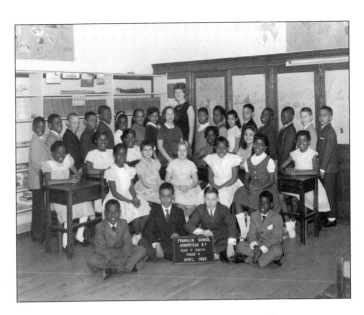

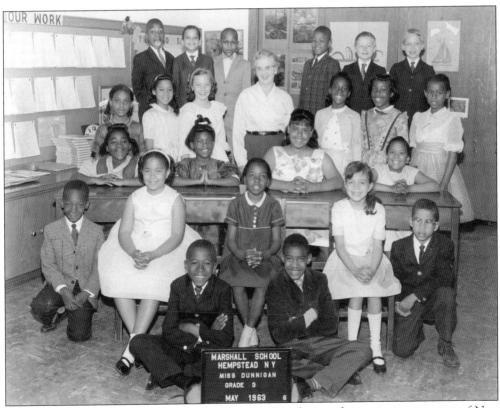

Kneeling at far right is David Alexander Paterson, best known for serving as governor of New York from 2008 to 2010. An early optic nerve infection left him nearly blind; his parents moved to Hempstead because the school system agreed not to place him in special education. He earned a BA in history from Columbia University and a law degree from Hofstra University. Fulton Street School was renamed David Paterson Elementary School in his honor.

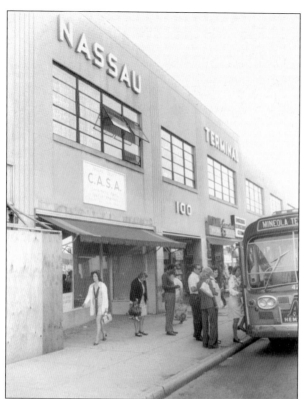

Coordinated Agency for Spanish Americans (CASA) located an office in the former Hempstead Bus Terminal in the mid-1960s, indicating the increasing presence of Spanish-speaking residents. Black students and occasional Asian students were visible at Hempstead High; not so visible were immigrant students, especially Latinos, who, from 1957, quietly attended Hempstead schools when surrounding schools refused them. The 2010 census showed Latino residents composing 45.9 percent of the village population.

In 1961, The Salvation Army Church on Atlantic Avenue at the north end of Terrace Avenue was built. The church immediately supplied various social services and remains a clarion voice both in advocacy for the poor and in ministering to village residents in need. It is not directly connected to the Salvation Army Men's Facility and Thrift Shop that has existed since 1941 on Front Street.

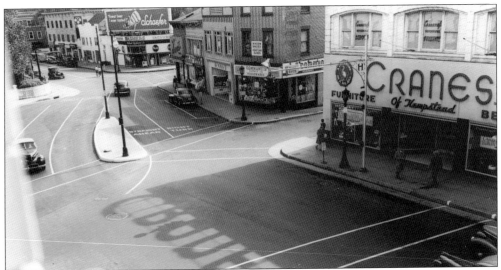

By the end of the 1960s, this complicated intersection of Main Street and Front Street had been reconfigured. As the photograph shows, Main Street once dead-ended from the north (from the left) into Front Street at Cranes, while Little Main Street, Greenwich Street, and Liberty Street dead-ended into Front from the south. Traffic had always been difficult in "the Hub," and this intersection had to be solved. The reconfiguration eliminated Liberty Hall in 1968.

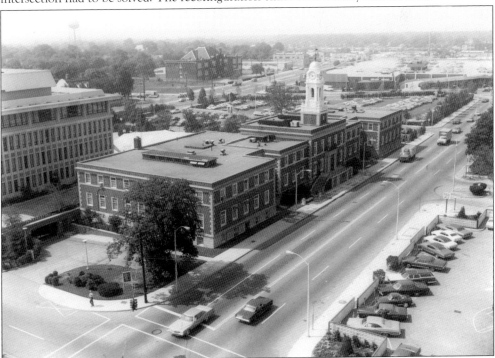

After 1968, Liberty Street became a lane through the expanded Town of Hempstead Town Hall parking lot. Main Street now jogs eastward at Front Street, becoming Greenwich Street across Peninsula Boulevard. The immense Times Square Store on the west side of Little Main, visible here with its rooftop parking beyond the town hall parking lot where formerly stood Liberty Hall, was replaced by a successful business plaza during the 1990s.

The 1922 Hempstead High burned in 1970. Its replacement on President Street was already under construction. After the fire, Hempstead High students attended classes in St. George's Episcopal Church, Our Lady of Loretto Roman Catholic Church, United Methodist Church, and other organizations until the replacement was completed. The middle school that soon arose on the burned site was rededicated in 1984 as Alverta B. Gray Schultz Middle School, honoring a Hempstead educator.

This 1969 architect's rendering of the 1970 Hempstead High School displays the structure still in use. Despite fluctuating graduation rates, honors have been earned: Long Island High School of the Year in 1981; Darrick Heath, 1990 Olympic handball team; Gold Award in chorus, director Rachel Blackburn, 2017 New York State School Music Association Festival; Best Performance Group for the marching band under Benjamin Coleman, March 2017, Rockville Center St. Patrick's Day Parade.

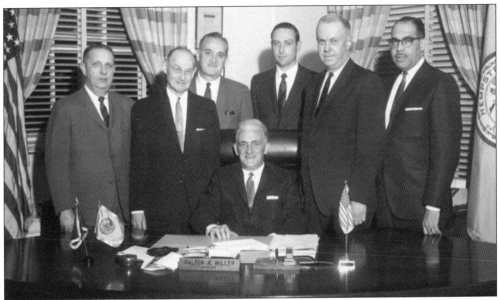

Mayor Dalton Miller is shown here in about 1970 with the Hempstead Village Board of Trustees and village attorney, including Russell Service, who, in 1969, became the first African American to serve on the Hempstead Village Board of Trustees. Standing from left to right are trustees Ed Conners and George Noon, village clerk Andrew Petrie, village attorney Sol Horowitz, and trustees Brom Williams and Russell Service. Mayor Miller is seated.

Mayor Dalton Miller presides over the ribbon-cutting for Harold Mason Park on April 3, 1971. Mason was a Hempstead resident killed in combat in Vietnam. The tiny park on the southeast corner of Jackson and Washington Streets provides active, safe equipment for young children and welcoming benches for parents. The park stands behind the Hempstead Public Library.

121

Julius "Dr. J." Erving, who spent his elementary school years in Hempstead and was coached in youth basketball by Don Ryan, appears here in 1973 to greet children at the Salvation Army Community Center. Erving became one of the greatest basketball players of all time, particularly notable for transforming the slam dunk into a magnificent leap executed at the end of skilled maneuvers—his signature move. (Don Ryan.)

Don Ryan has been involved with coaching youth sports teams for the Police Athletic League and the Salvation Army for 56 years. Also, he taught business for 33 years at Hempstead High School. In May 1975, *Long Island Newsday* ran a lengthy article about Ryan in its "Long Island's Master Teachers" series. He is pictured below at far right in 1998 with Julius Erving (left), Robert Parish (center, wearing tie), and Salvation Army team members. (Don Ryan.)

Eight

A Different Kind of Hub

1980–2017

The March 1981 elections brought the first-ever Democratic Party village trustees: A. Patricia Moore, far right, a lawyer and teacher who was also the first female trustee in the village; and John Van Buren, second from right, Hempstead school board member and Hofstra University professor. George Milhim, center, was elected mayor over Dalton Miller, who had served since late 1967.

James A. Garner, a member of the village board of trustees from the mid-1980s, became Hempstead Village's first African American mayor in 1989. He is shown here third from left with village justice Lance Clarke, second from left; A. Patricia Moore and George Milhim, fourth and fifth from left; and Russell Service, far right. During Garner's four terms, the Times Square and the Abraham & Straus Stores closed, then redeveloped into enduring business plazas.

In March 2005, after serving for six years as a Hempstead Village trustee, Wayne J. Hall Sr. became Hempstead's second black mayor and its first Democratic mayor. After he served as a medic in the US Army in Germany and in Virginia, Hall and his wife, Derrah, moved to Hempstead in 1978. They raised their two sons in Hempstead. He served as mayor until 2017. (Antonio Kelley.)

Kenneth I. Chenault, born and raised in Hempstead, was educated at the nearby Waldorf School. The Bowdoin College and Harvard Law School graduate is a longtime businessman who has been chairman and chief executive officer of American Express Company since 2001. His creative leadership brought the 167-year-old firm to widely acclaimed corporate stability. Chenault's name made *Fortune* magazine's 2014 inaugural list of the World's 50 Greatest Leaders.

The former Black History Museum, begun in 1969, continues at 110 north Franklin Street as the African American Museum under Dr. Joysetta Pearse and her husband, Julius. Dr. Pearse, shown under the museum's sign, has managed the museum since 2012. She is the executive director of The African-Atlantic Genealogical Society (TAAGS). The museum hosts permanent and rotating displays, adult and child activities, and local events. (RB.)

Senior councilwoman Dorothy L. Goosby, a community activist, moved to Hempstead in 1968. In the early 1980s, she won a lawsuit forcing Hempstead's Republican Party to allow Democratic Party meetings in Kennedy Park. In 1999, she sued the heavily Republican Town of Hempstead because no African American had ever been elected to it. She then ran as a Democrat, won, and has served as councilwoman ever since. (Dorothy Goosby.)

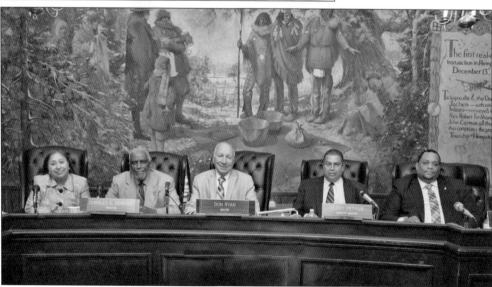

Don Ryan, pictured center, after 16 years as a village trustee, was elected mayor in March 2017. Serving under him on the board of trustees are, from left to right, Gladys Rodriguez, a social worker whose husband Max was Hempstead Village's first Latino trustee in 1995; Charles Renfroe, local businessman and former school board member; Perry Pettus, local businessman and now deputy mayor; and Lamont Johnson, current school board member and retired village police officer. (Antonio Kelley.)

On August 22, 2017, somber-faced community leaders gathered at Hempstead Village Hall to express unity amid diversity after a tragic incident in Charlottesville, Virginia. Councilwoman Dorothy Goosby speaks at the podium. Pictured from left to right are (first row) Mindy Perlmutter, Jewish Community Relations Council; Village Trustee Charles Renfroe; Rev. Dr. William Albert Watson; Donna Raphael, Family and Children's Association; Dr. David Gates, Miracle Christian Church, Chief of Staff under Mayor Don Ryan (who is unseen but present); (second row) Kawaljit Chandi, Comité Cívico Salvadoreño, Inc.; Rev. Sedgwick Easley, Union Baptist Church; George Siberón, Hempstead Hispanic Civic Association; unidentified; (third row) businessman Henry Holley; Rabbi Michael Eisenstein, Congregation Beth Israel; Rabbi Art Vernon, Congregation Shaaray Shalom, West Hempstead; (fourth row) Barbara Powell, Nassau County Comptroller's Office; village trustee Lamont Johnson; Rev. Yolanda Richardson; and Eric Wingate, Glen Cove Community Development Agency. (RB.)

Discover Thousands of Local History Books
Featuring Millions of Vintage Images

Arcadia Publishing, the leading local history publisher in the United States, is committed to making history accessible and meaningful through publishing books that celebrate and preserve the heritage of America's people and places.

Find more books like this at
www.arcadiapublishing.com

Search for your hometown history, your old stomping grounds, and even your favorite sports team.

Consistent with our mission to preserve history on a local level, this book was printed in South Carolina on American-made paper and manufactured entirely in the United States. Products carrying the accredited Forest Stewardship Council (FSC) label are printed on 100 percent FSC-certified paper.

MADE IN THE USA